les femmes

by J. H. Lartigue

A Dutton Visual Book

E. P. Dutton & Co., Inc.

New York 1974

779

First published in the U.S.A. by E. P. Dutton & Co., Inc., 1974

Published simultaneously in Canada by Clarke, Irwin & Company Limited, Toronto and Vancouver

Translated from the French by Translation Company of America

ISBN: 0-525-49500-2

Library of Congress Catalog Card Number: 74-3638

Designed by Jacques Maillot

Printed in France

CONTENTS

PARIS

A blackbird sings. It is the music of springtime in Paris.

Ten years old: I was not aware that my memory was unconsciously being charged. Simone, with her "Royal Fern" fragrance. I still remember the name of that perfume, the first perfume of my loves . . . Sixteen years old . . . Seventeen . . .

Eighteen years old: Madeleine, with her short hair and blue eyes. We played together at school, and one look from her was worth all the embraces of all the women on Earth. Smells of tar, horse-dung and hawthorn. Hot air enveloped the thicket, paralyzing me. I felt exhausted, and yet I had run so well and been the unexpected winner of so many of the foot races that day! Sweat ran down my radiant face. Was it a storm cloud or the warm mist, that great, somber background against which the chestnut blossoms glowed? In the heat, all around me, the song of the blackbird took flight in a crowning, glorious tune.

Twenty years old: the springtime of my springtime. The Bois de Boulogne, my head ached, my legs felt weak. I was perplexed. Exhausted. Twenty years: two springtimes, one on top of the other, were too much.

Springtime! I believed in it. I believed I imagined it. I imagined I believed it.

Many years later: this morning I am living in springtime. How could I believe in it, when it is unbelievable? How could I dare imagine it, when it is unimaginable?

I feel a desire to paint everything, photograph everything, write about everything. As has happened each time I have made love in the morning, I have an inconceivable urge to absorb all the rays of light and reflect them back into the faces of my friends.

1925 CROIX DE NOAILLES

A table in the forest. A whispering forest. The song of the nightingale comes from everywhere. From far away, from close by. It explains distance, the air. It tells of springtime. It comes from everywhere and jolts my memory, reminding it of so many forgotten things. It recounts all the loves of my life. It reminds me of all the things that had filtered through the coarse sieve of my memory and been forgotten. Reviving all the wonderful imponderables of the past.

She is tender, like all the new leaves. It is warm. My mind is empty. I am hungry. A path . . . We walk in the greenery dappled with sunlight and shadows. A boundless forest arrests my sight all around me: to the right, to the left, in front of me, behind me, above and below me. It is boundless, immense, and small. The trees close in on me, follow me, as in a fairy tale. Kingdom of life, in which everything breathes, everything sings, sleeps or loves. A concentration of existence which envelopes you, as a sound or a perfume.

In the moss, a spider. She says: "Spider of the afternoon: love!" One day, the fairy took two drops of water from the lake, cut some ripe wheat, and set about making her doll, completing it with a little milk, some peach skin. Then, she killed a titmouse, took its brain and placed it in the head.

1926 ROYAN

The tide is coming in. The sea warms its waves on the burning sand. I walk in the waves. I walk on the sand. When I feel like it, I lie down in the coolness, or stretch out in the heat.

Six o'clock in the evening. Light bathes my body. I am naked on my balcony.

I await my SHE. She is prettying and perfuming herself with all her pleasure, painting herself ready to make love.

The columns of the balcony are haloed by the sun: not clear, unfocused and vague in my eyes. A scent of resin drifts in through the window.

Love swept over me a little while ago, like a gust of wind blowing the clouds away. For the first time since I arrived here I am emerging from the mist.

1918 AIX LES BAINS

Aix! The lake! A field of flowers! . . . She was naked. The grass smelled of love . . . the air was perfumed with love . . . the sun's rays were the color of love . . . Love drove me insane. I was mad with love for this love of all the springtime things which gave me their love.

1960 PARIS

My heart overflows with something light, strong, full of distance and hope. A talisman composed of all the fragments of love that each of my loves gave me. A talisman which, it seems to me, will always be there to console me one day, if that be necessary. Ready to dispense in my heart an imperceptible "treasury of love", which none of my loves will ever be able entirely to destroy.

It is so strong within me, so concentrated, that I have the impression that it will sustain and nourish me for my whole life. This is why I am not mad, laughing alone: for I am laughing at the future.

And as I am writing this morning without reason—above all, without reasoning—I want to say that this love that I have in my heart is of a different quality from the scraps of love which the passing darlings of my heart have to offer.

<div align="right">
Extracts from the diary of

J. H. Lartigue
</div>

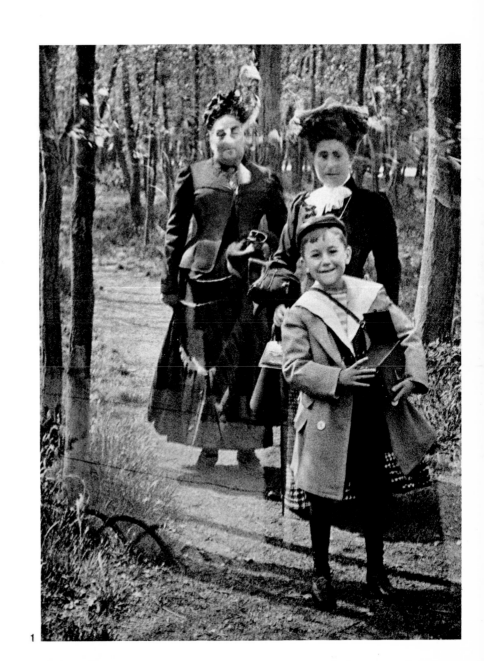

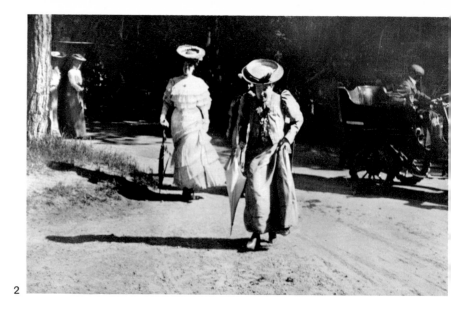

2

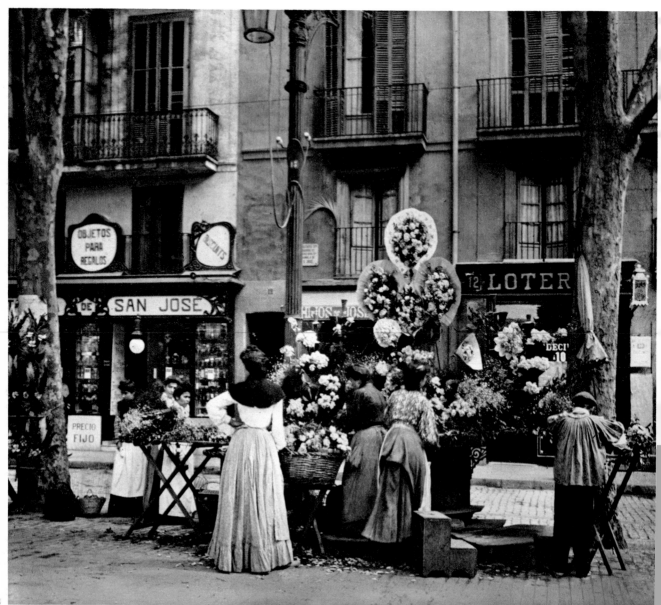

3

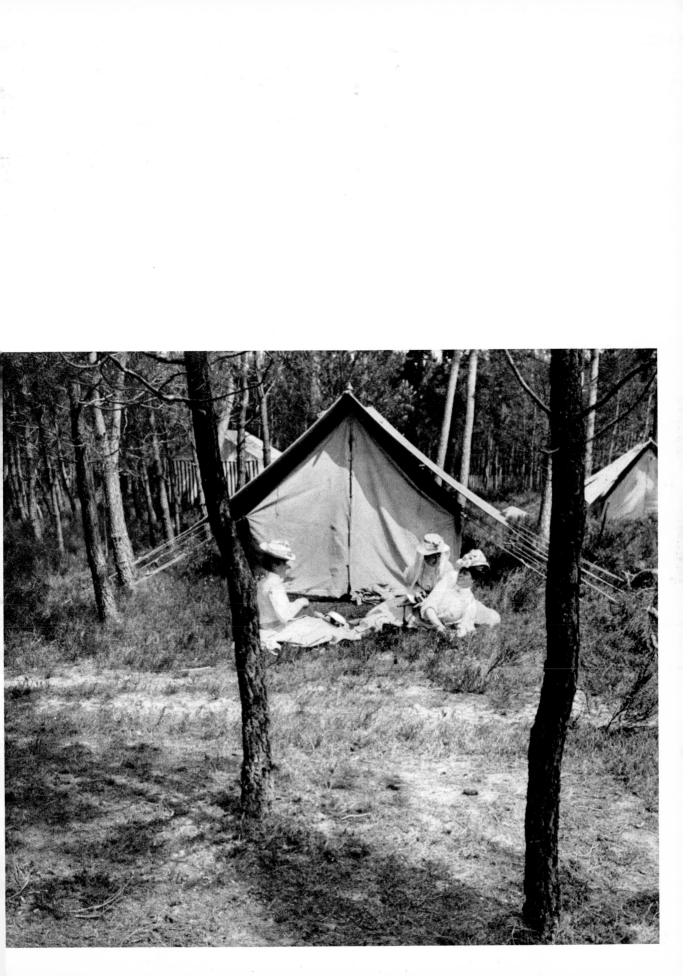

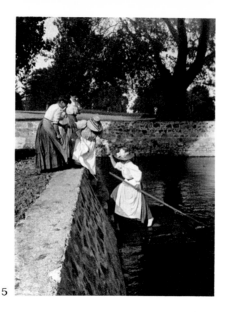

5

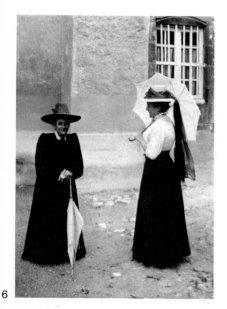

6

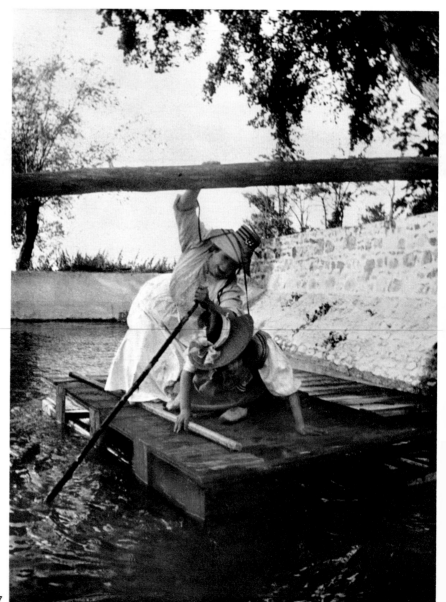

7

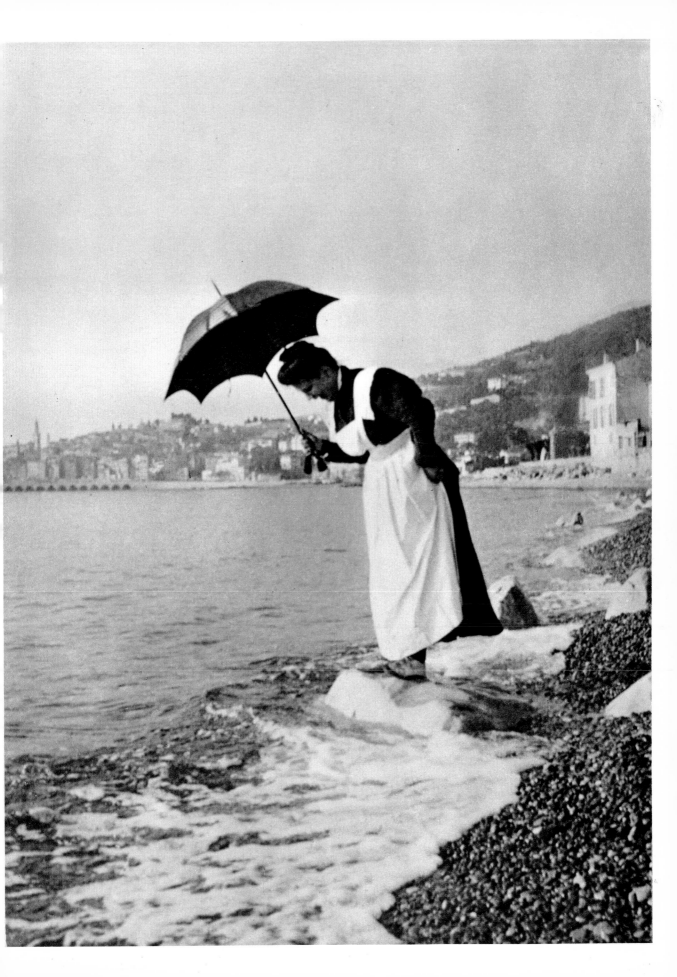

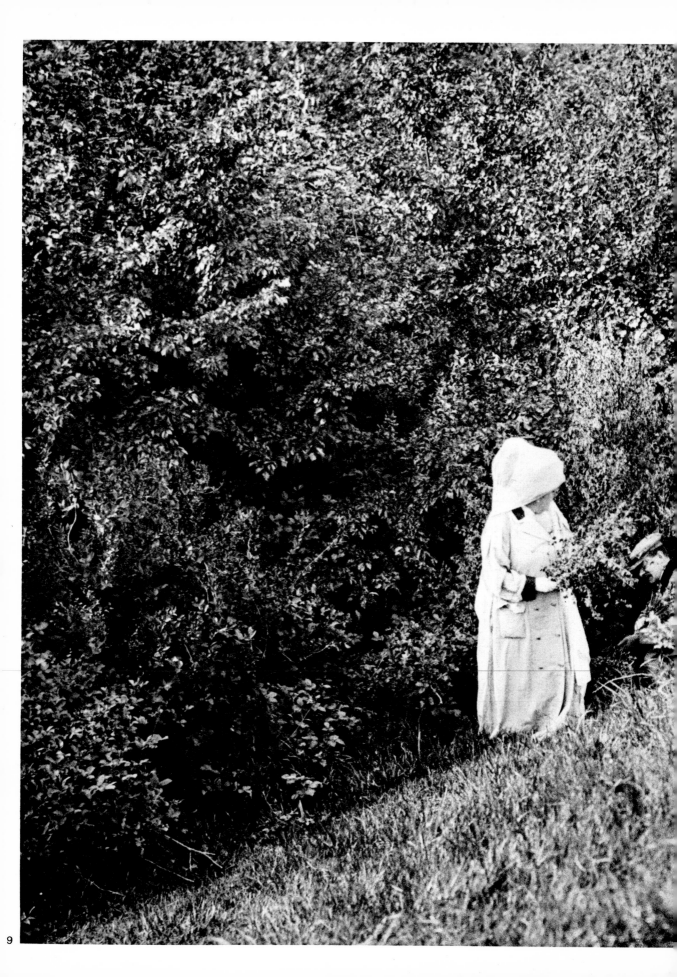

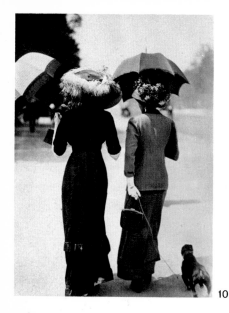

10

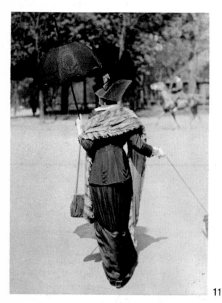

11

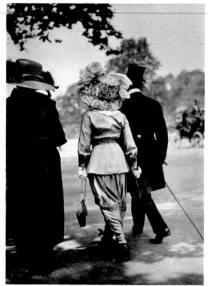

12

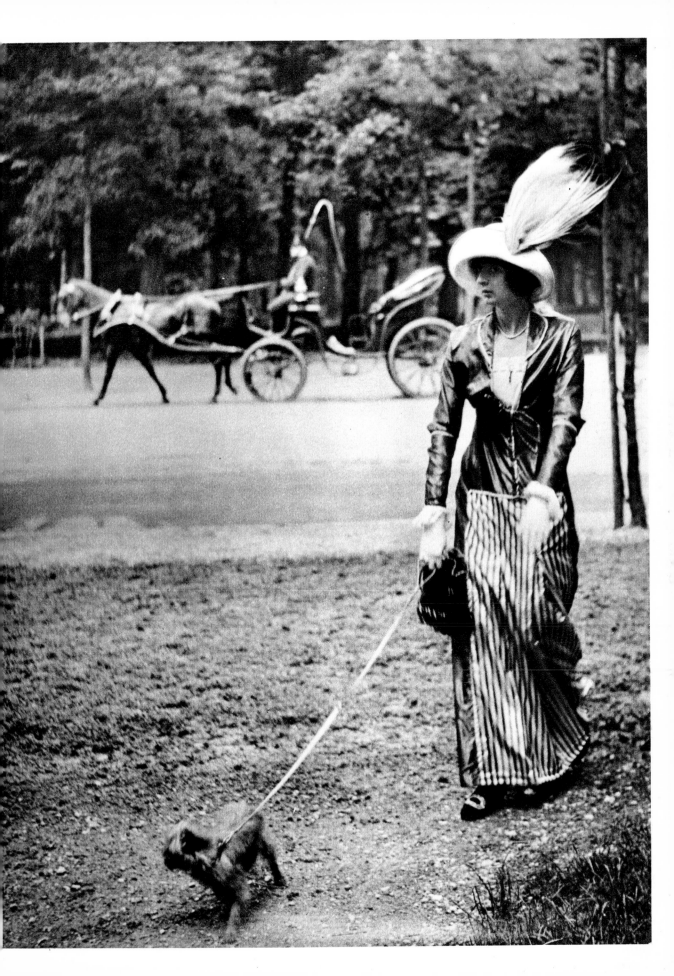

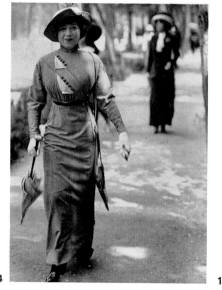

14

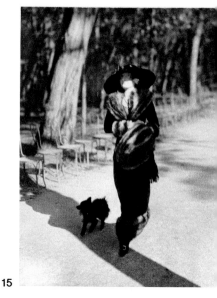

15

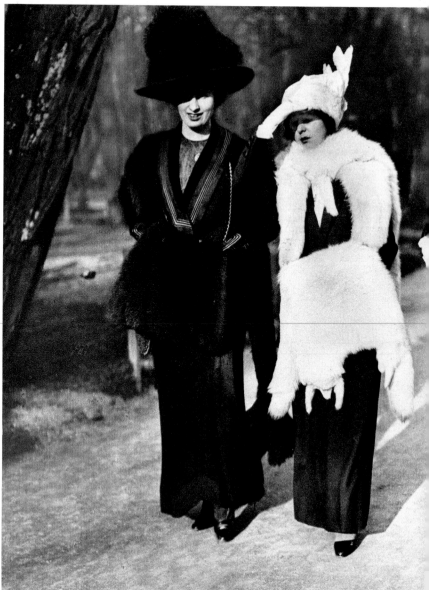

18

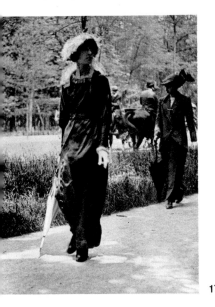

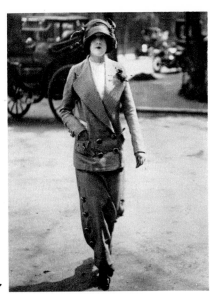

17

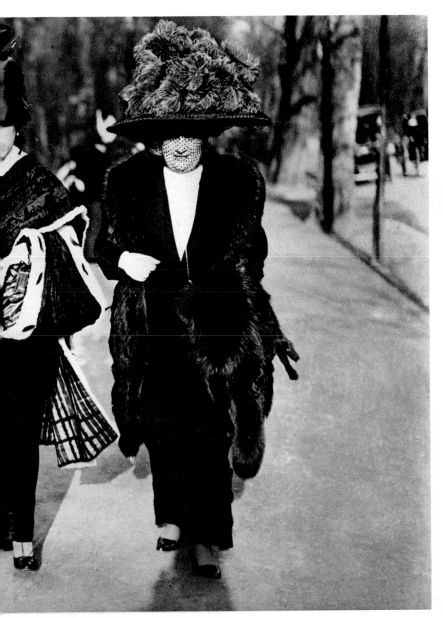

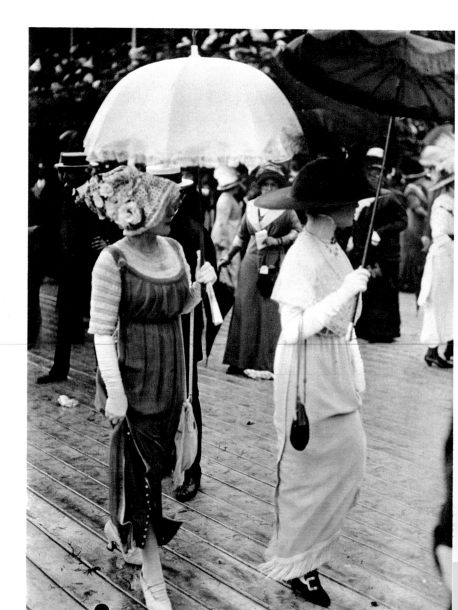

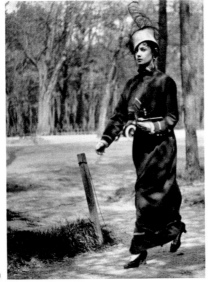

20

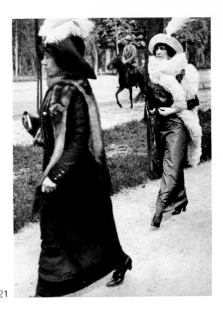

21

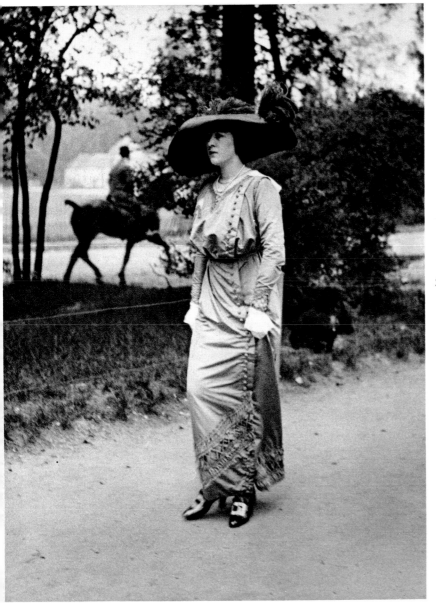

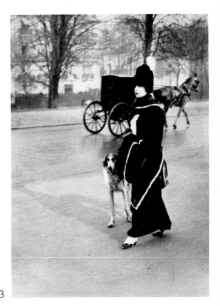

23

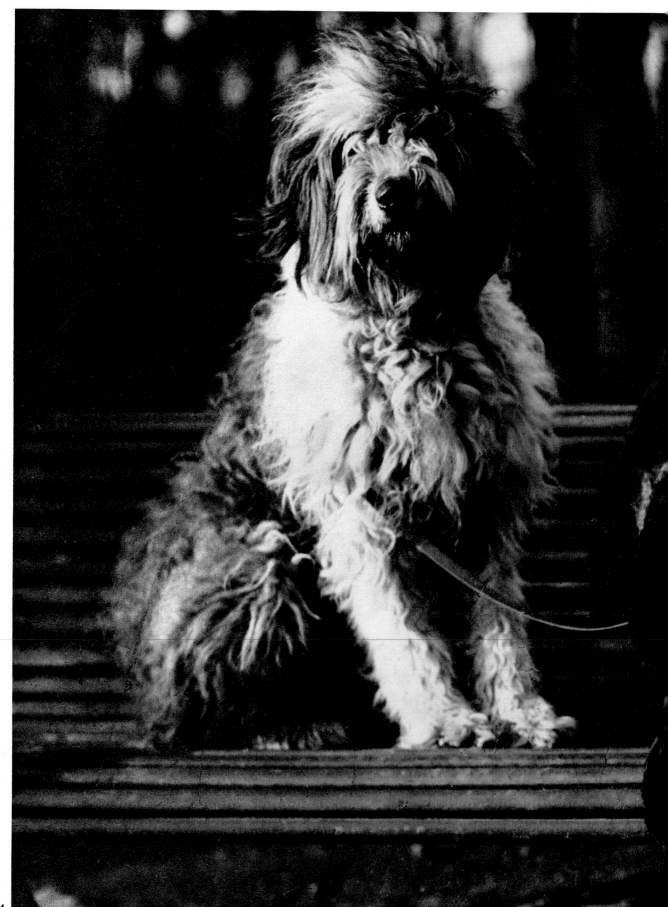

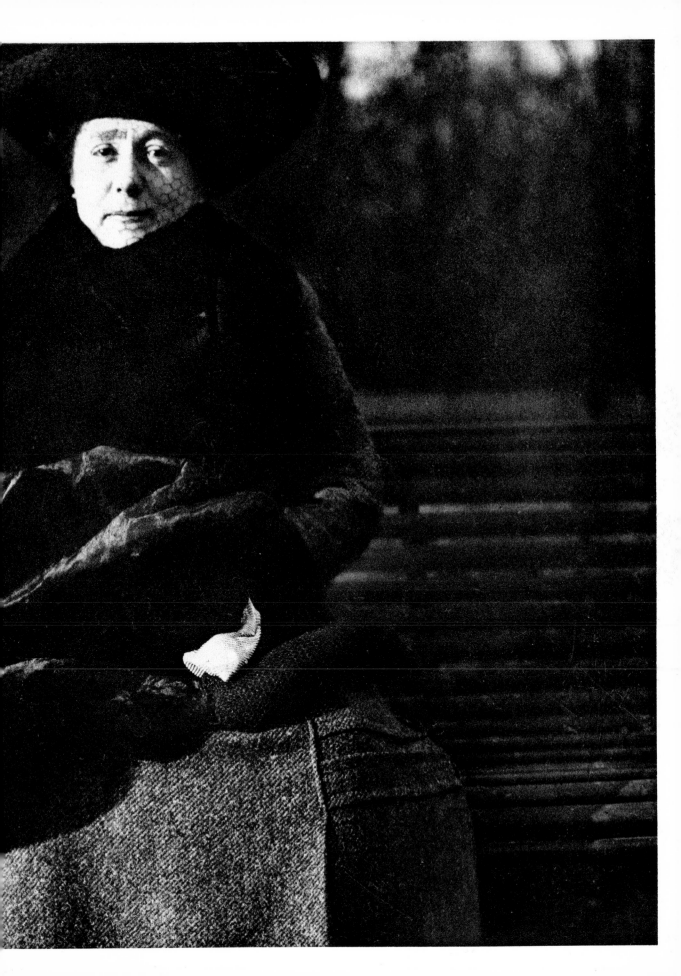

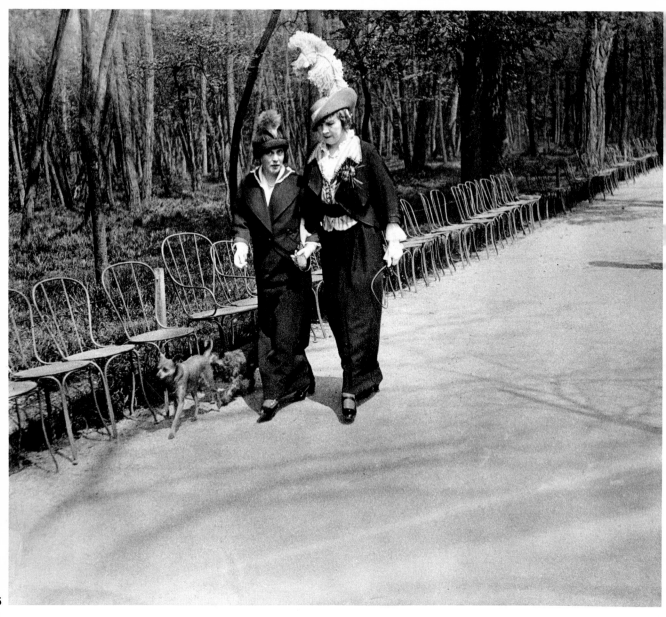

25

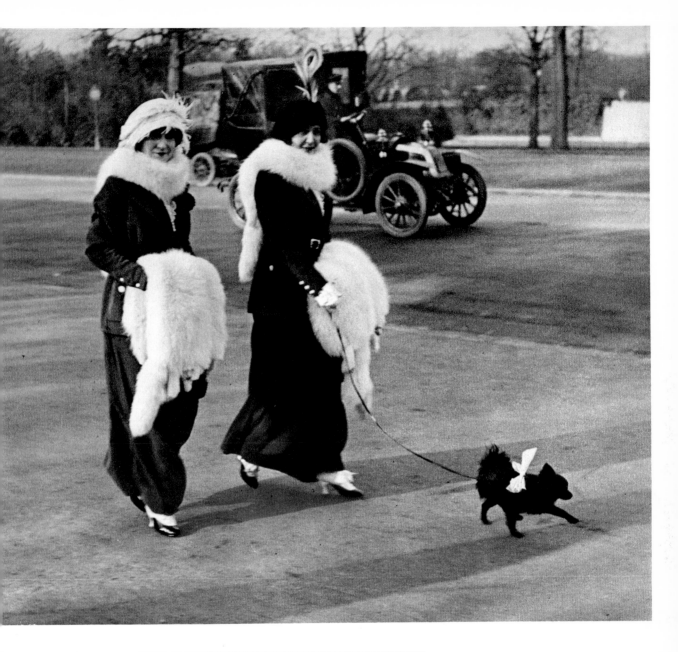

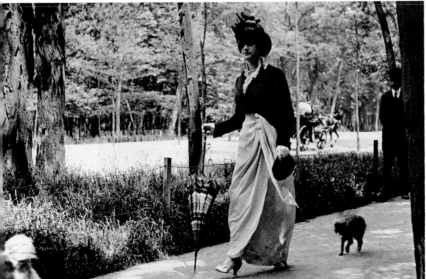

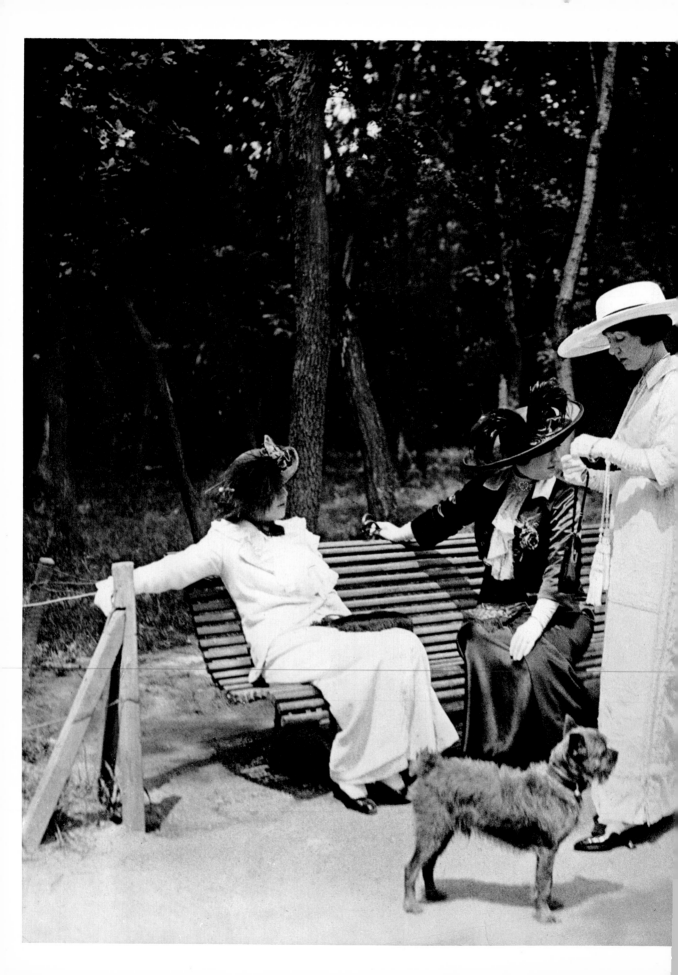

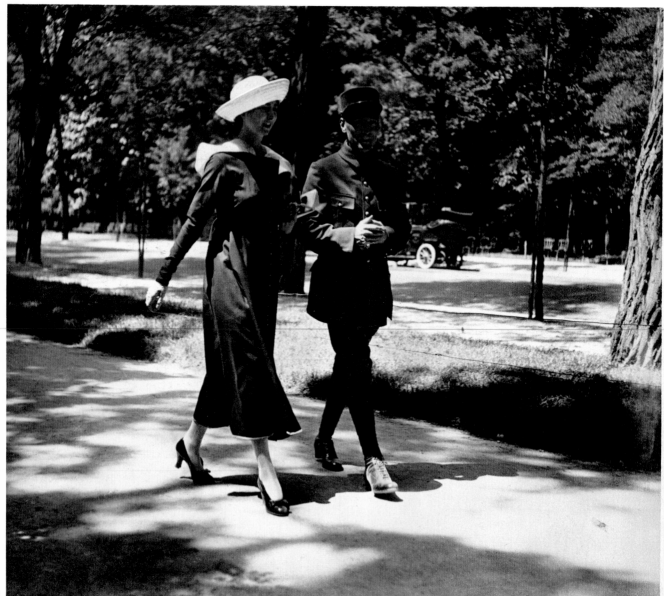

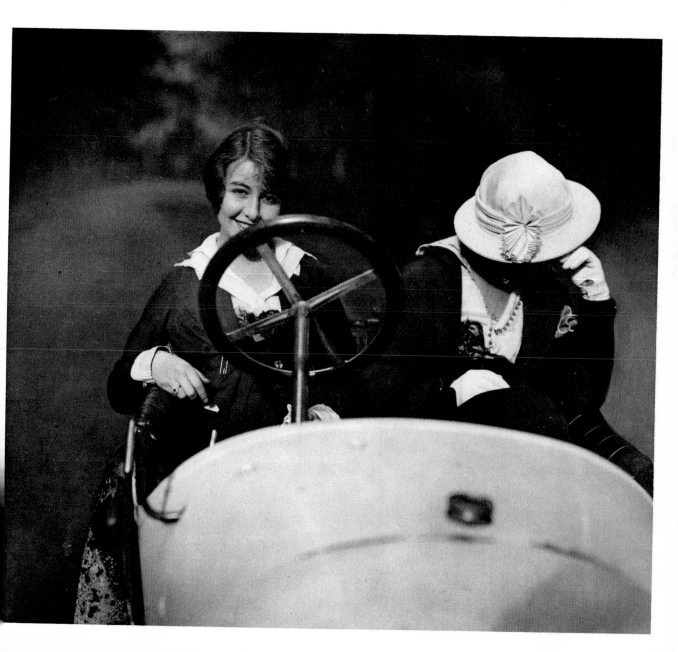

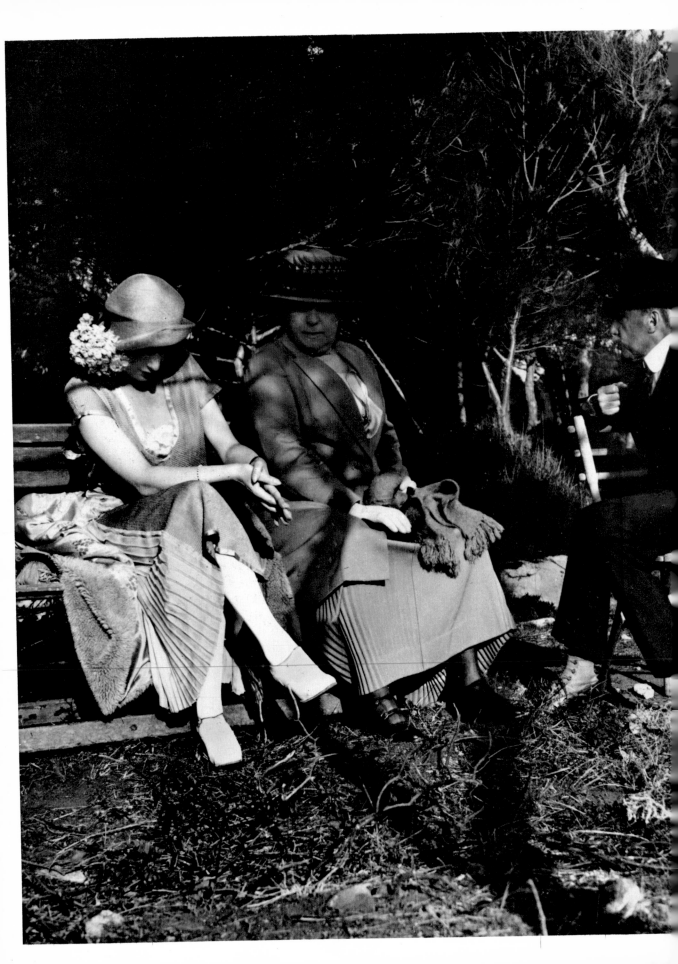

31

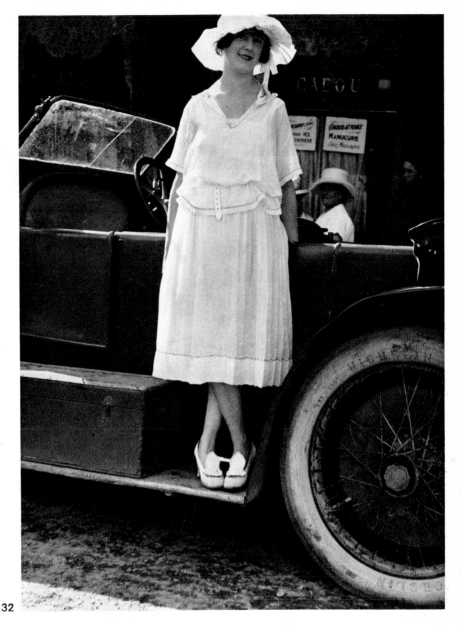

32

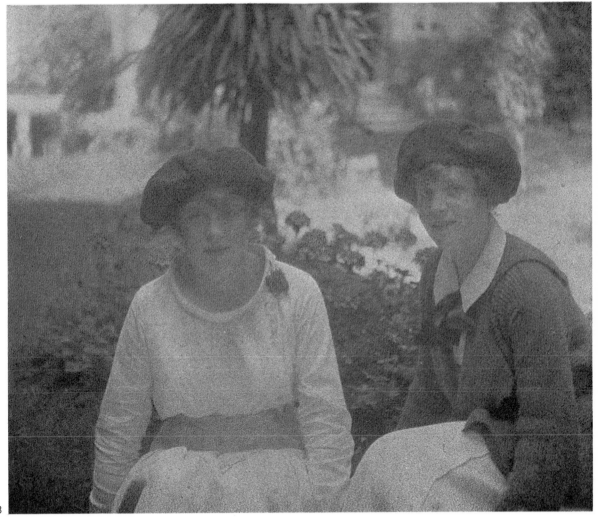

33

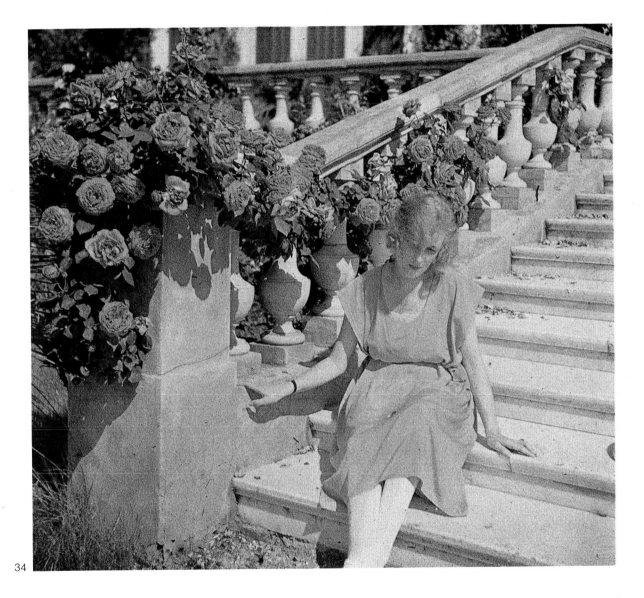

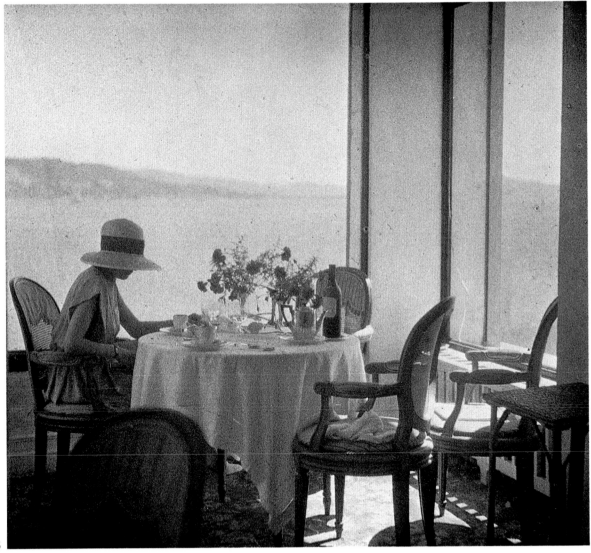

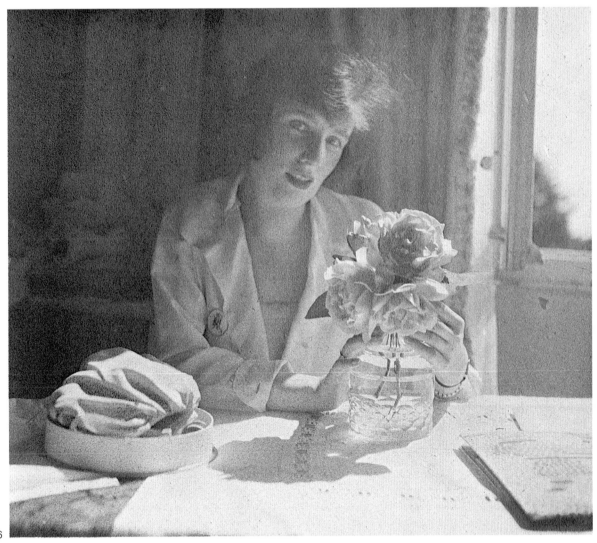

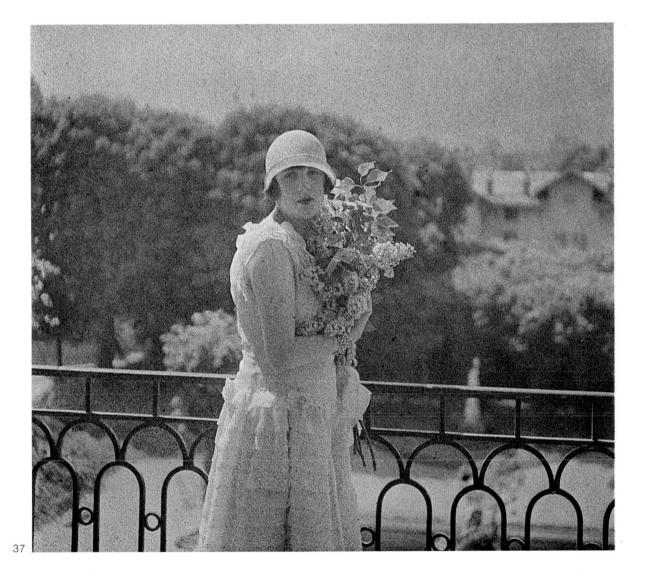

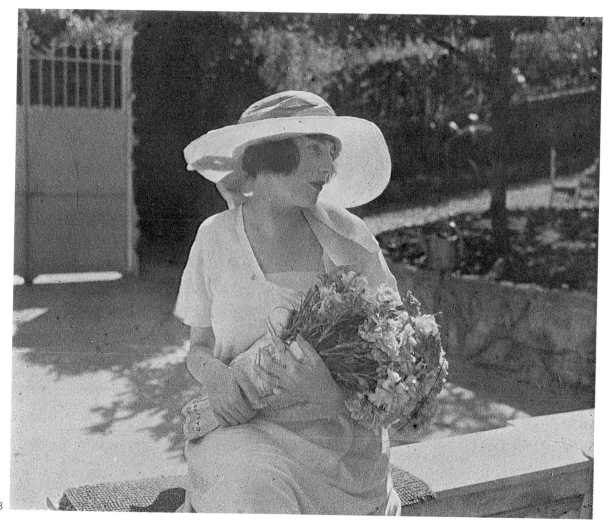

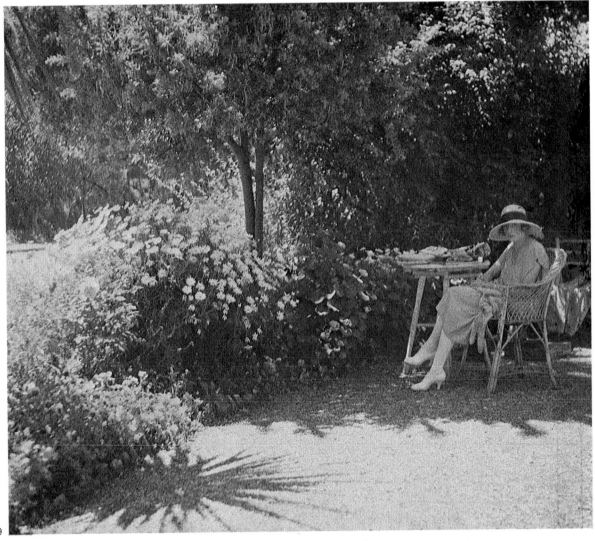

39

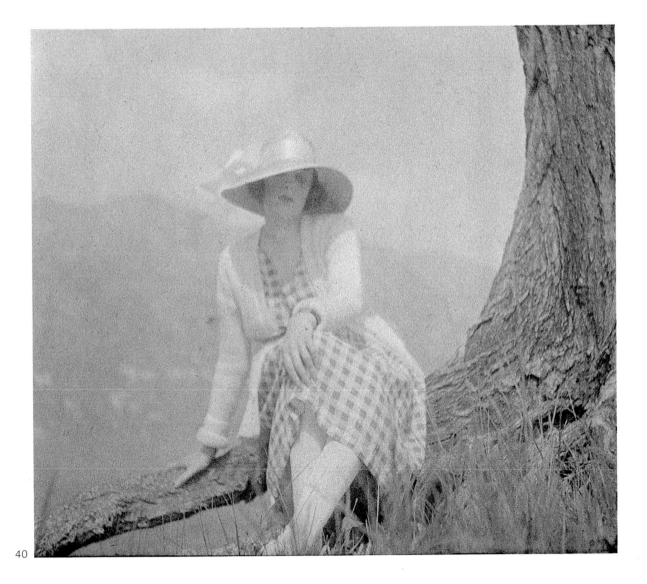

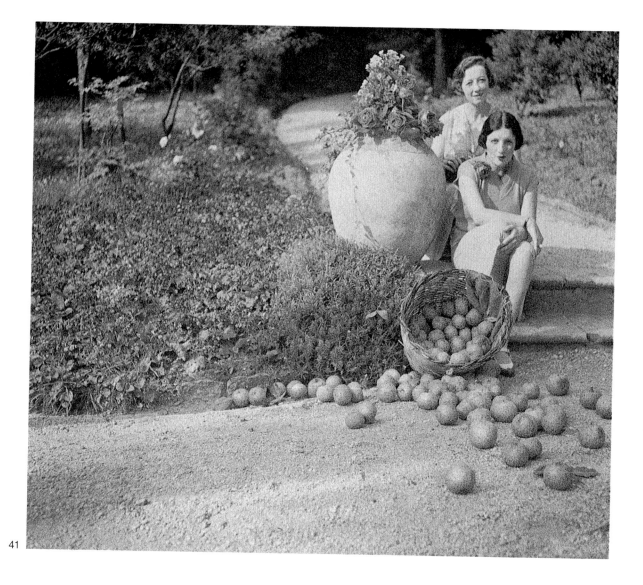

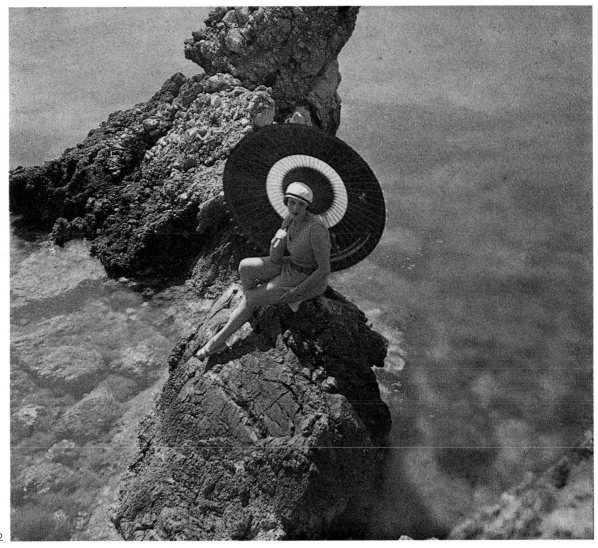

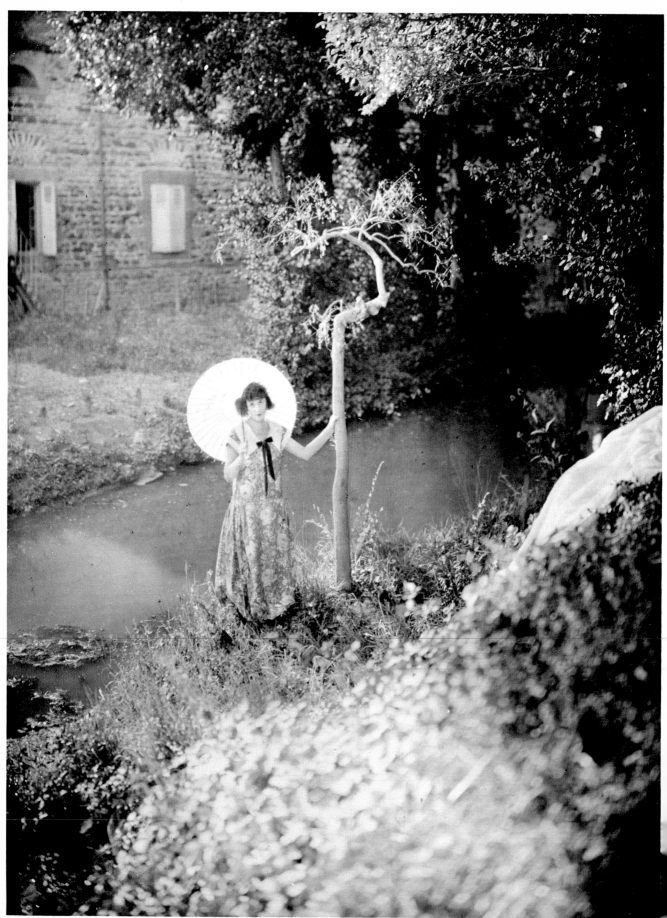

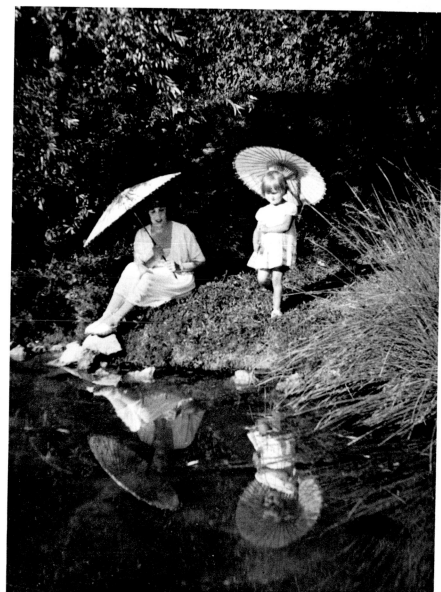

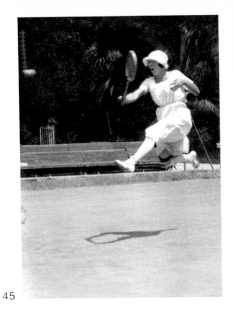

45

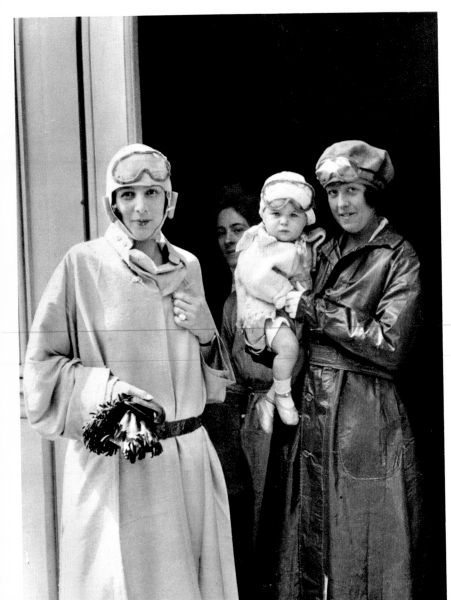

46

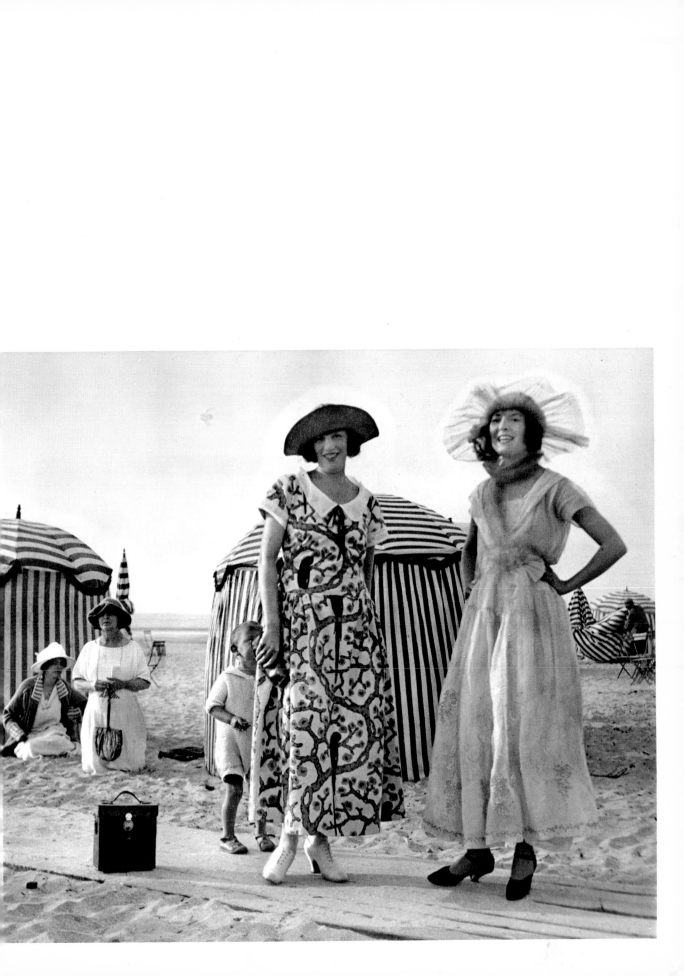

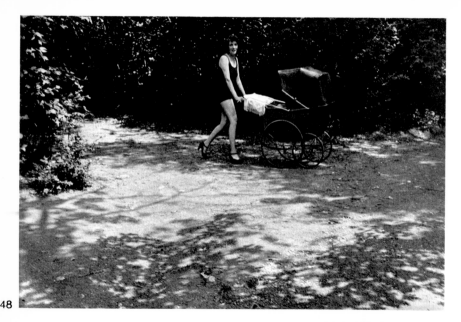

48

49

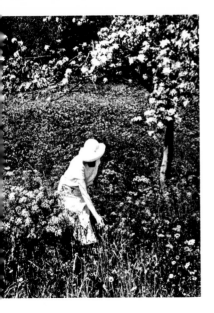

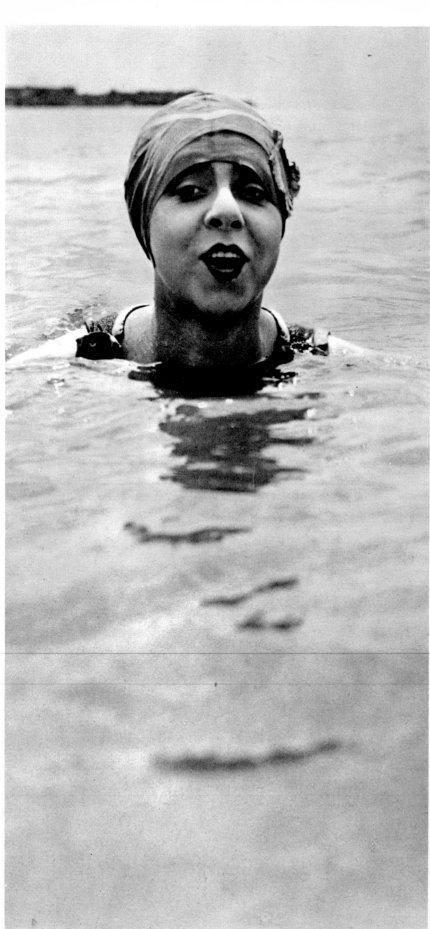

51

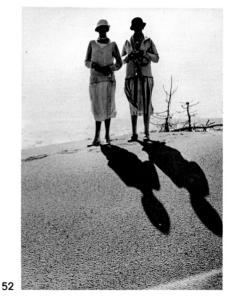

52

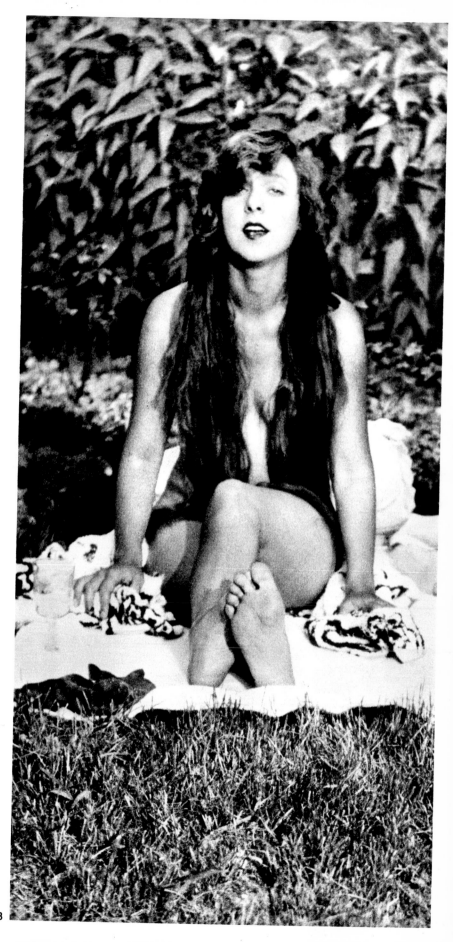

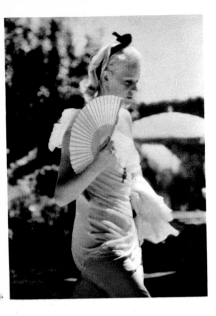

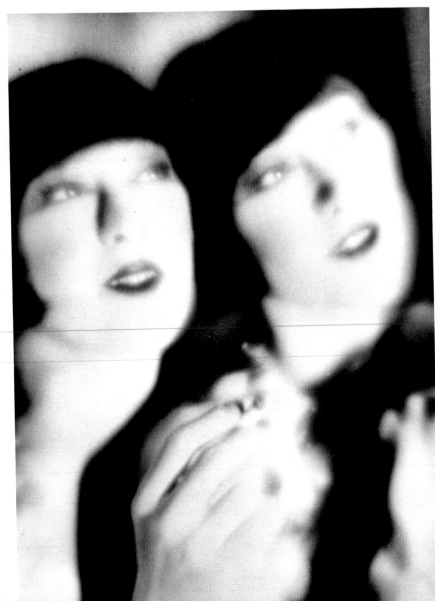

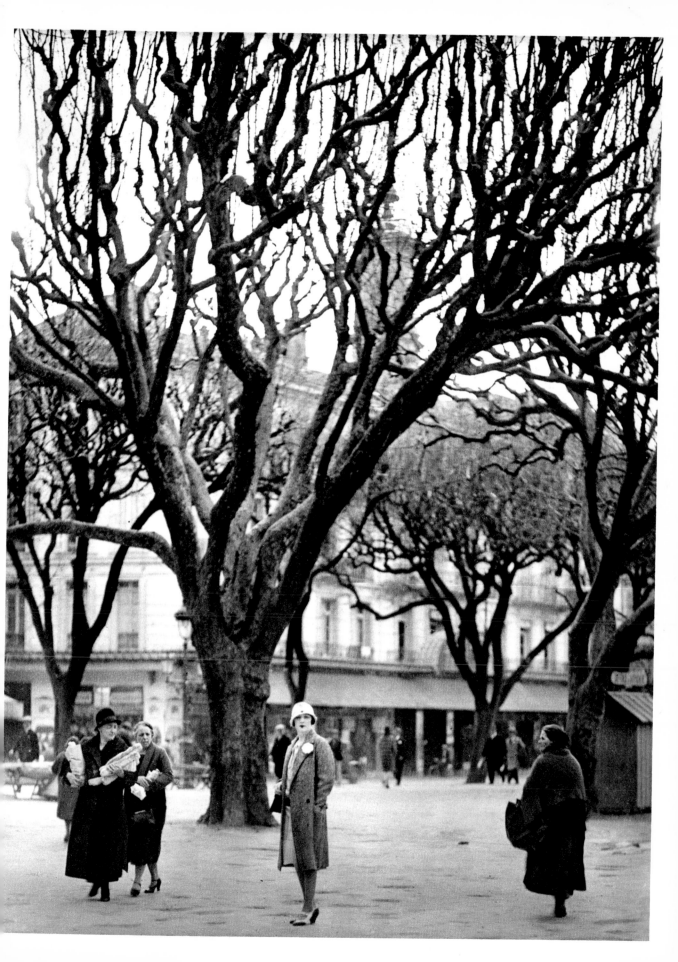

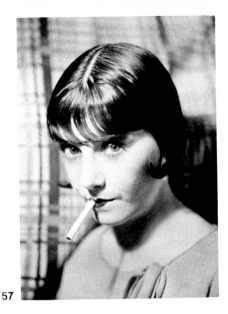

57

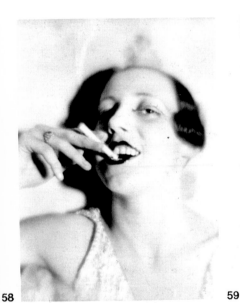

58

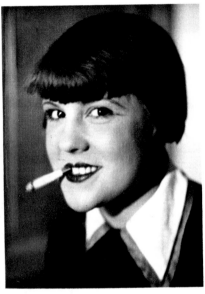

59

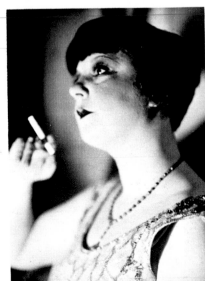

60

61

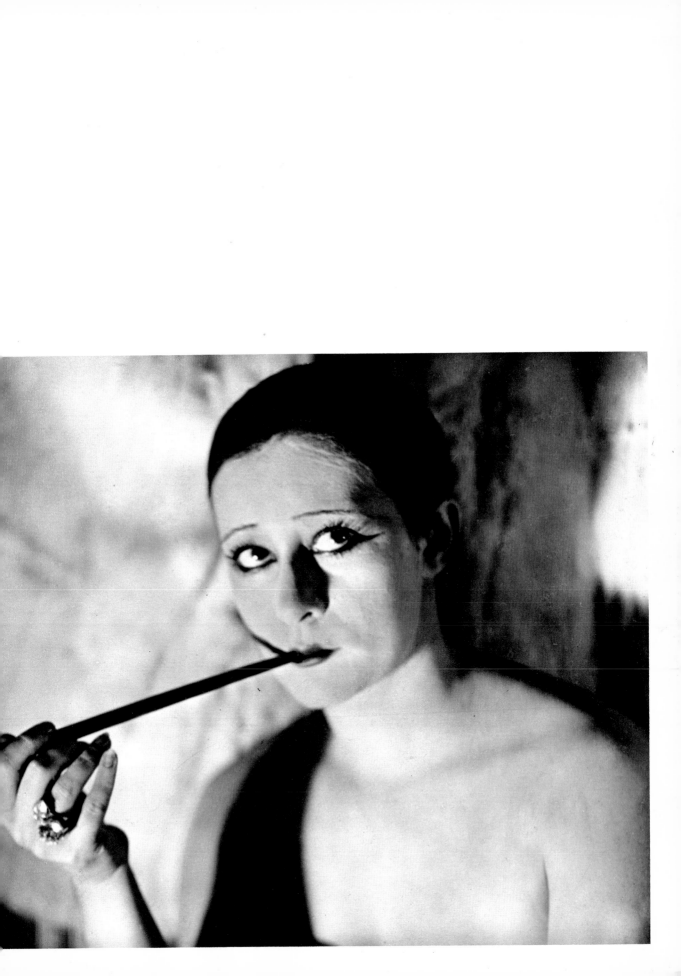

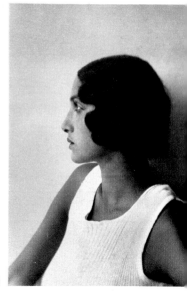

62

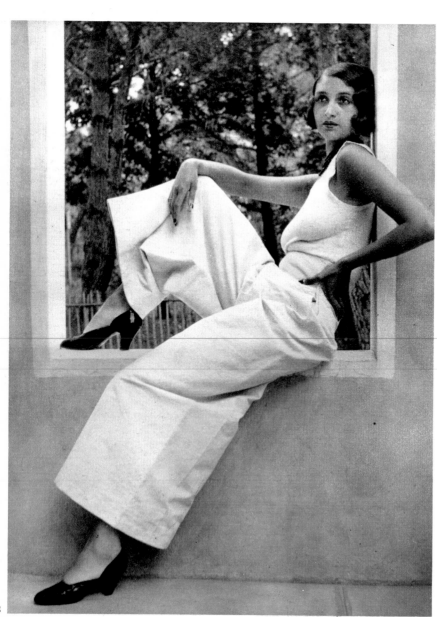

63

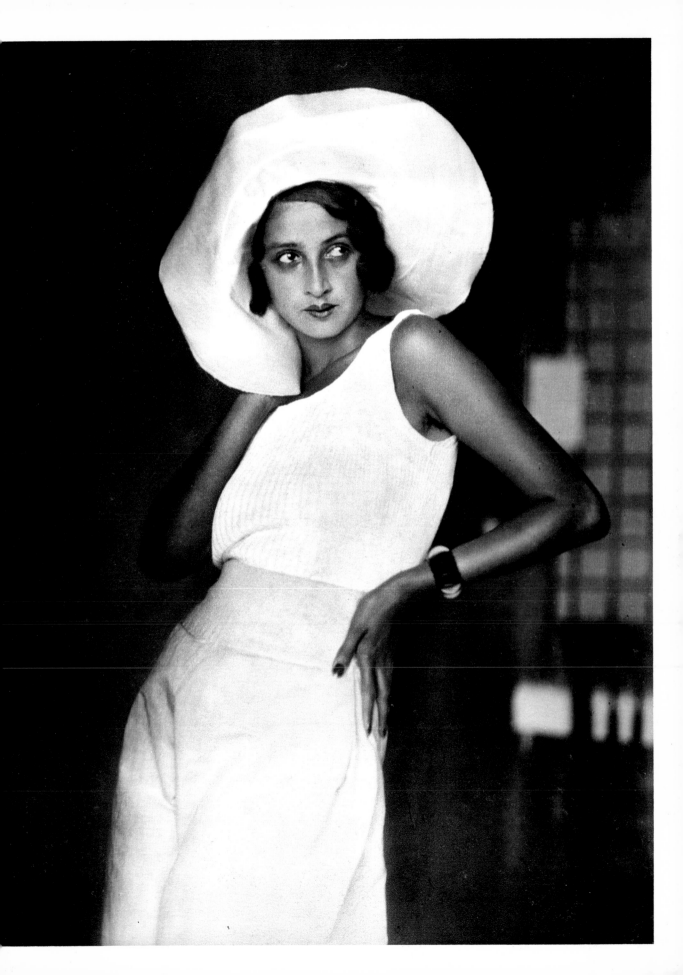

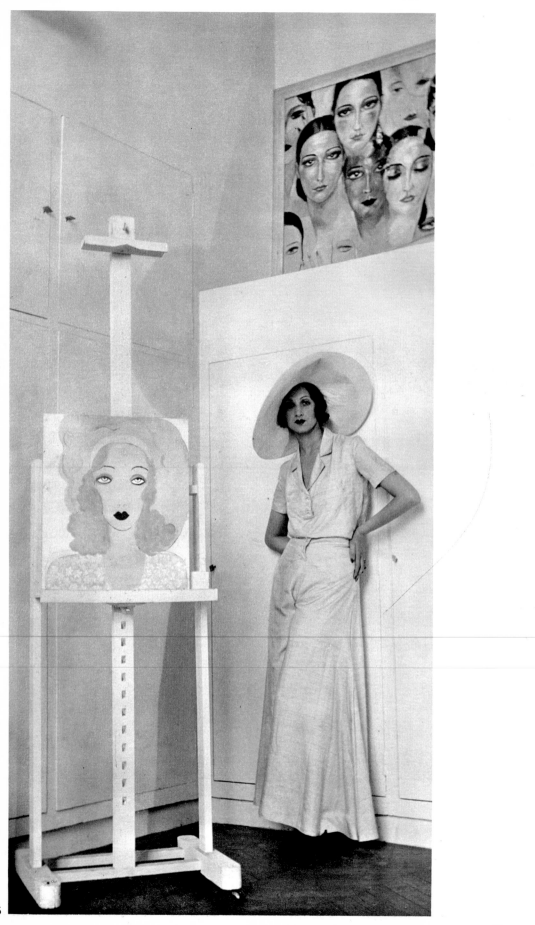

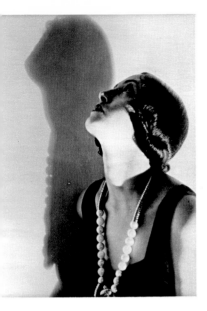

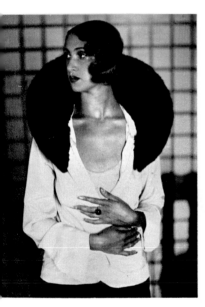

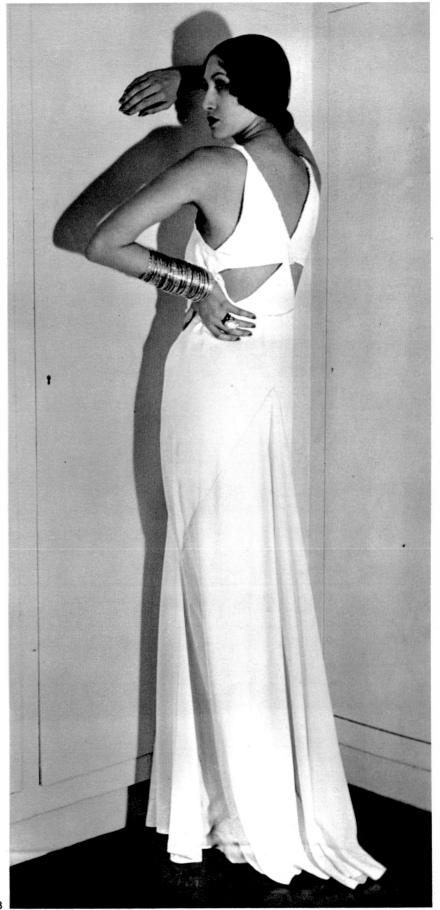

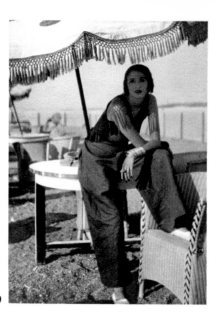

69

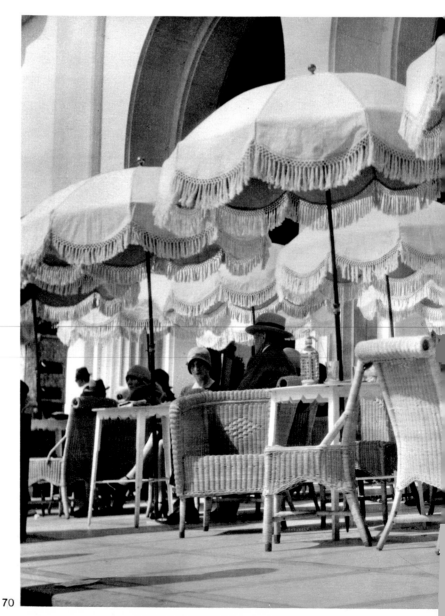

70

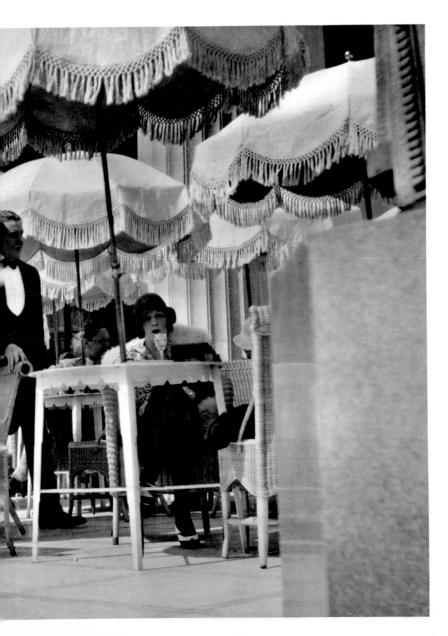

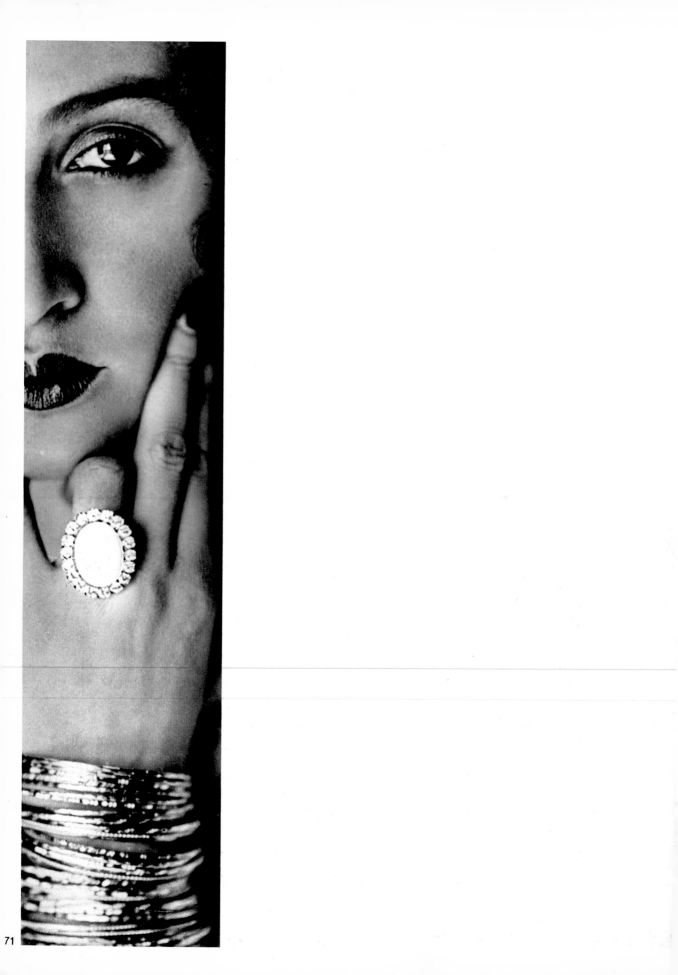

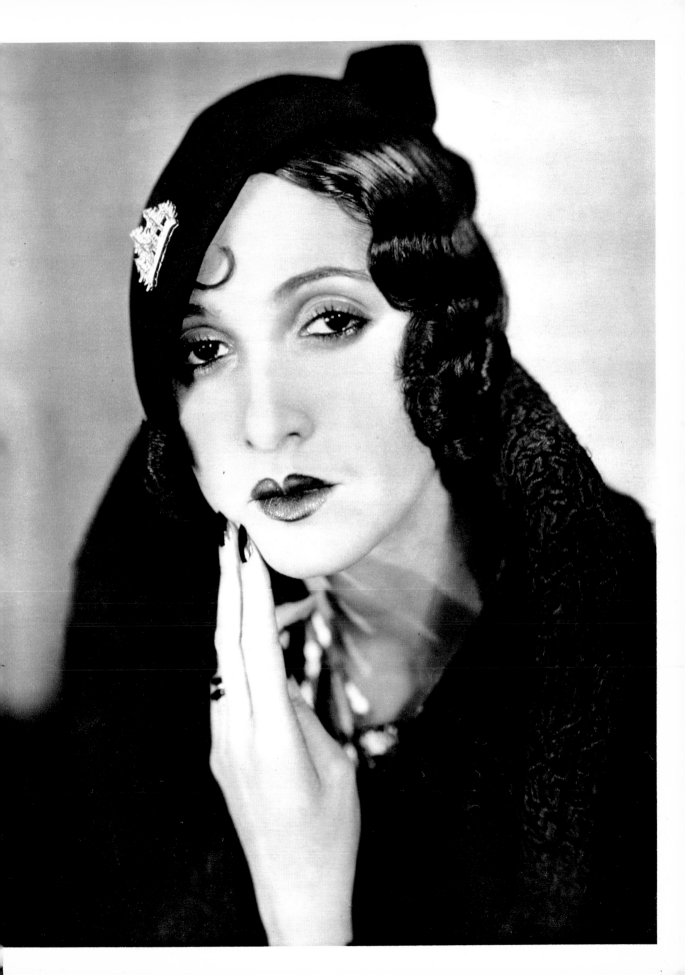

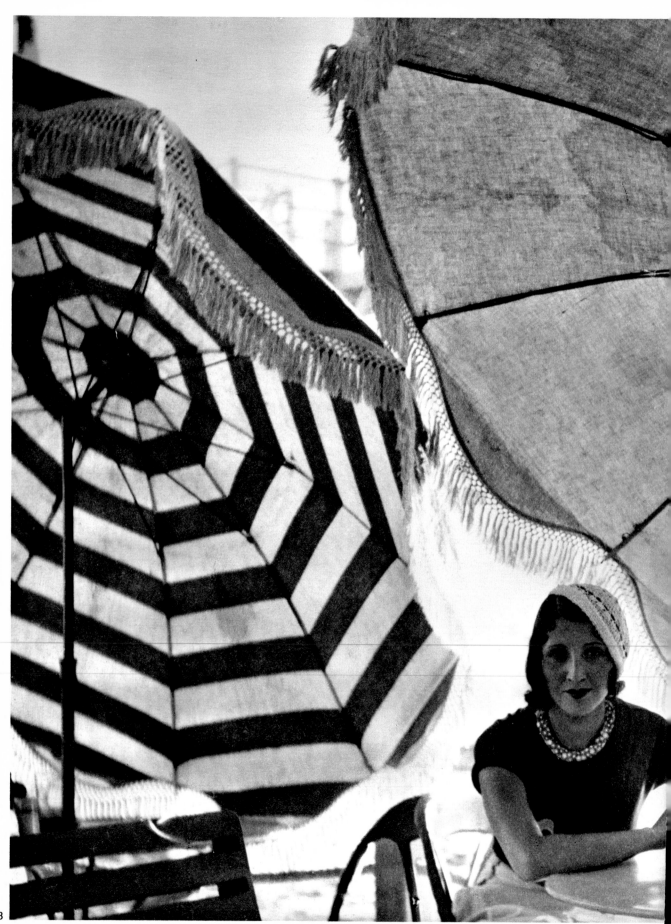

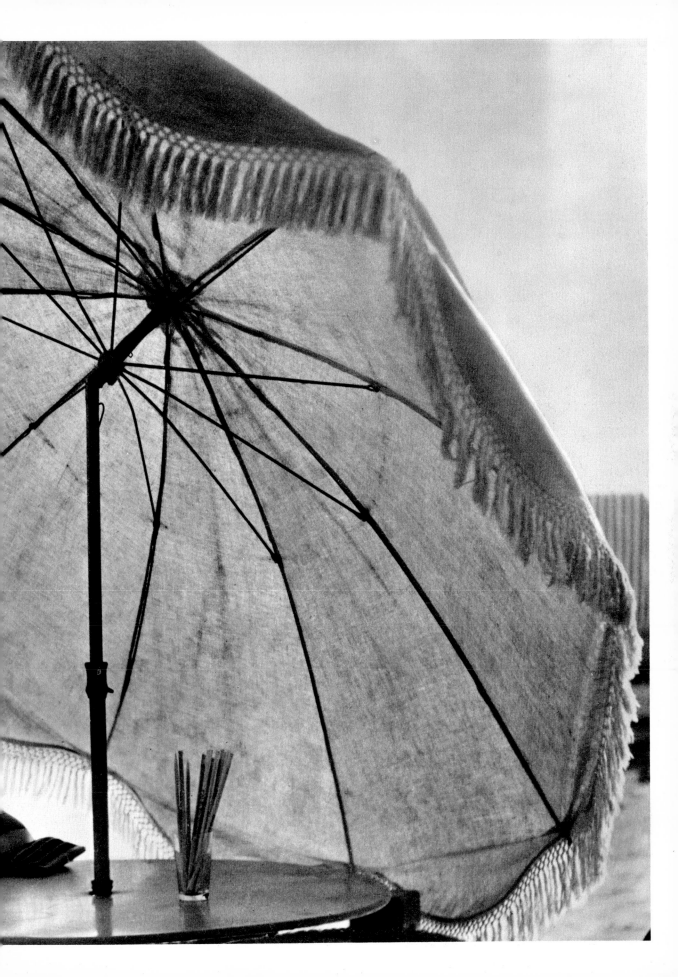

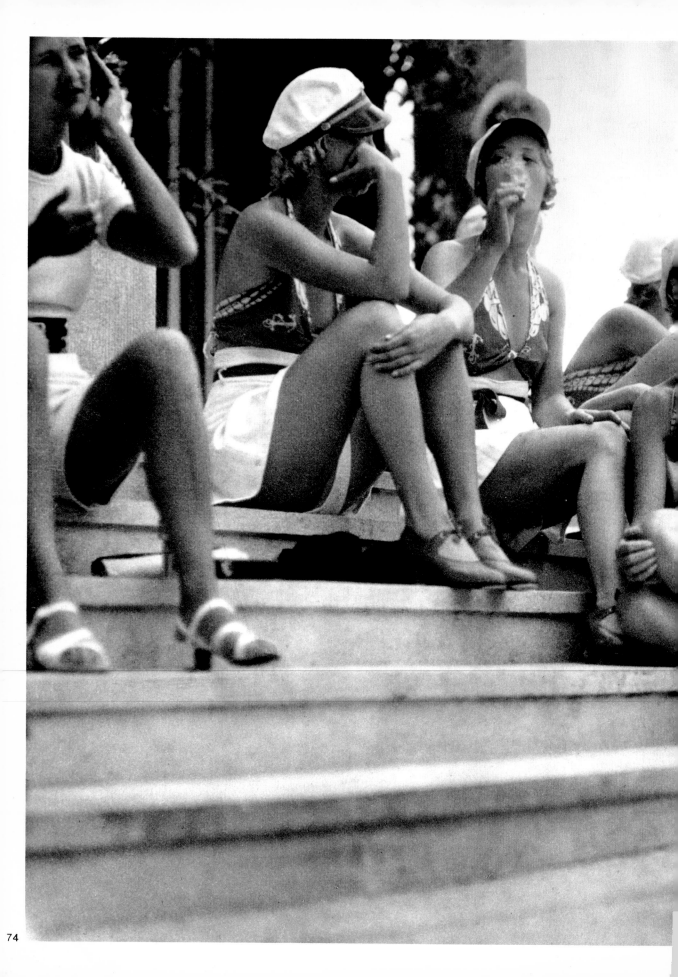

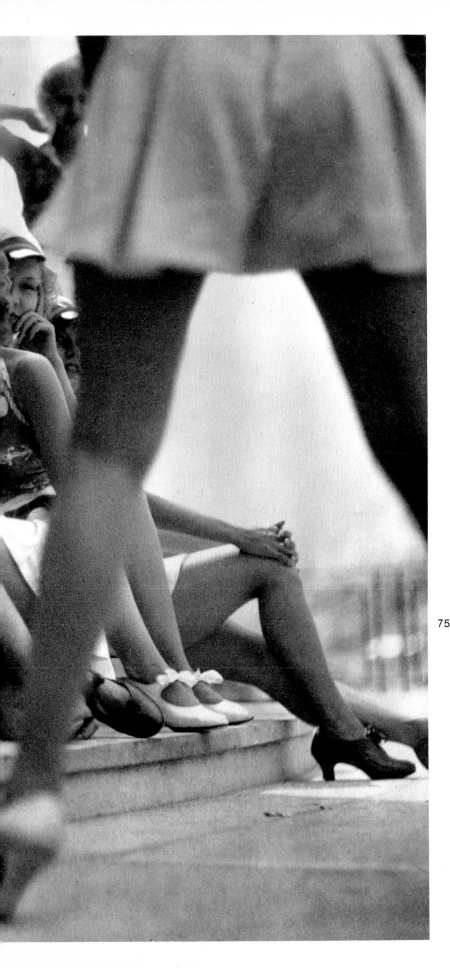

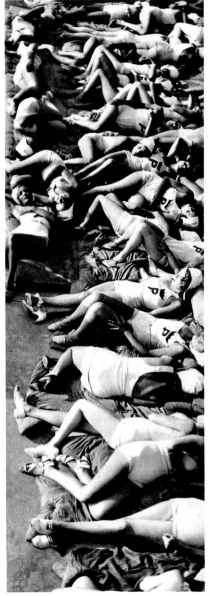

75

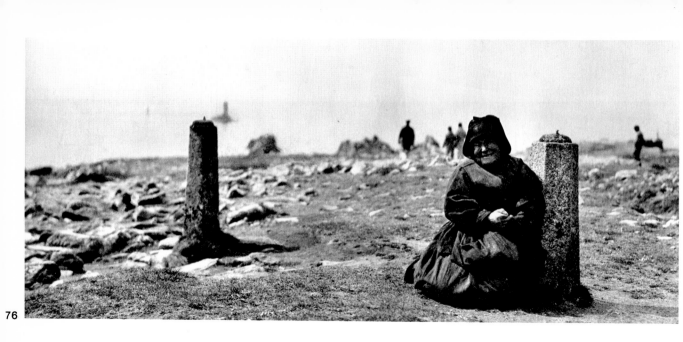

76

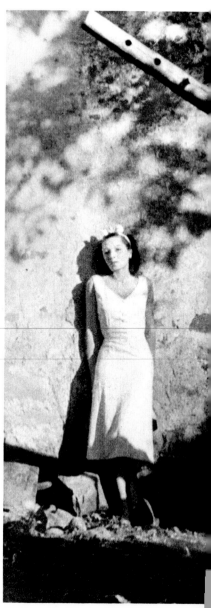

77

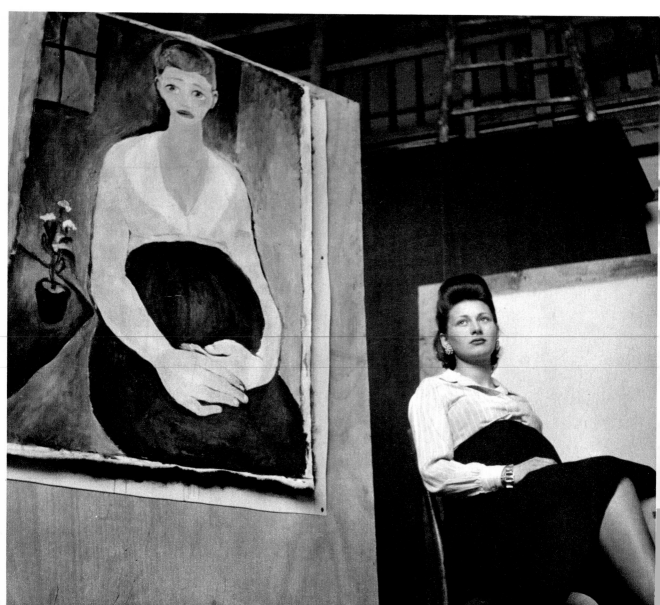

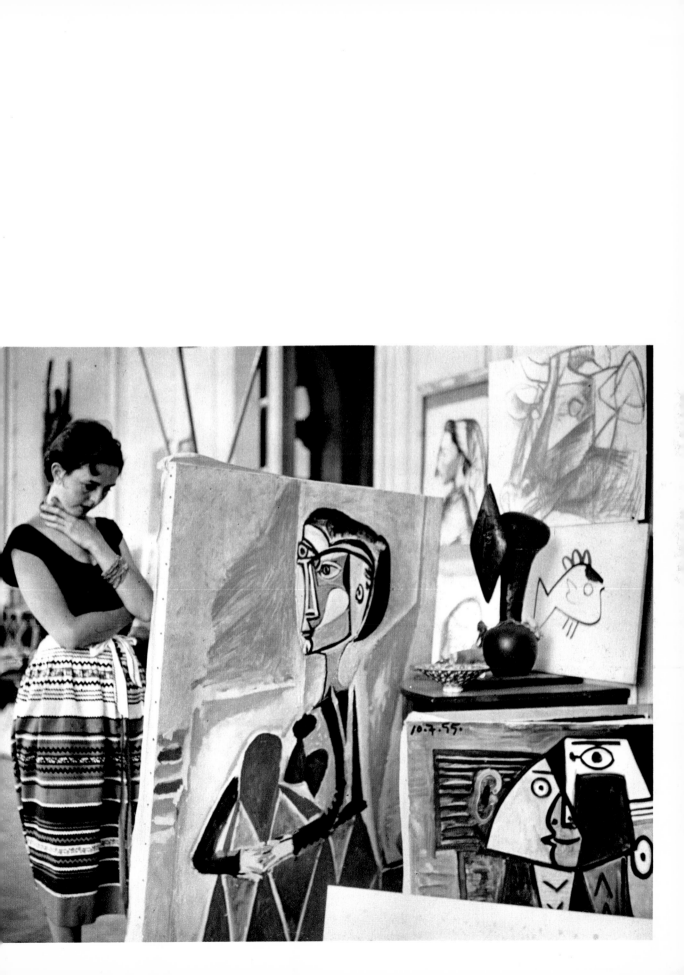

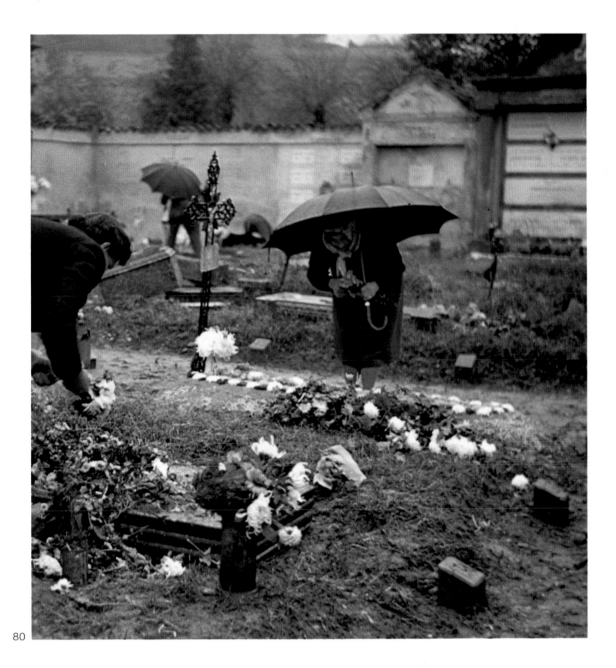

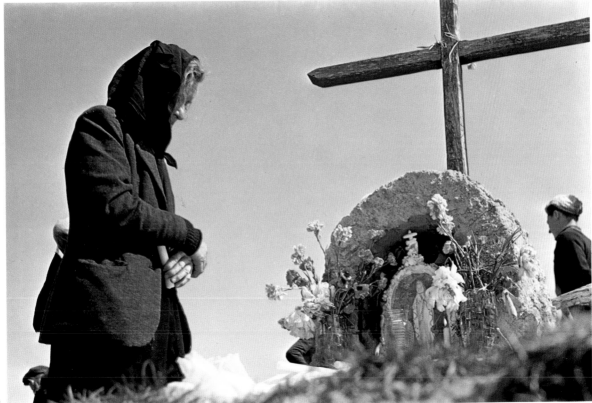

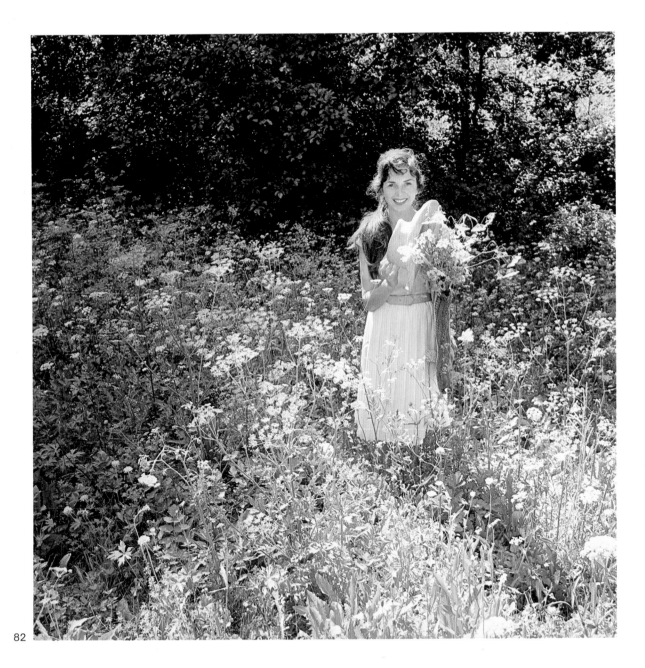

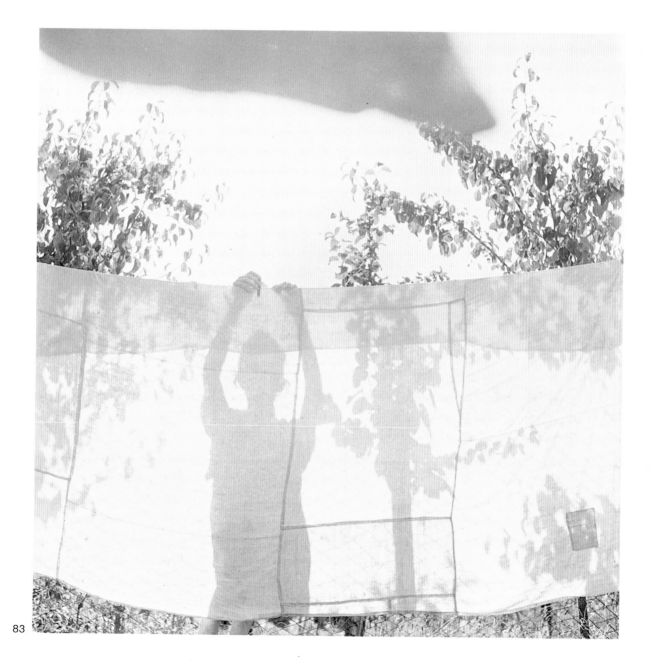

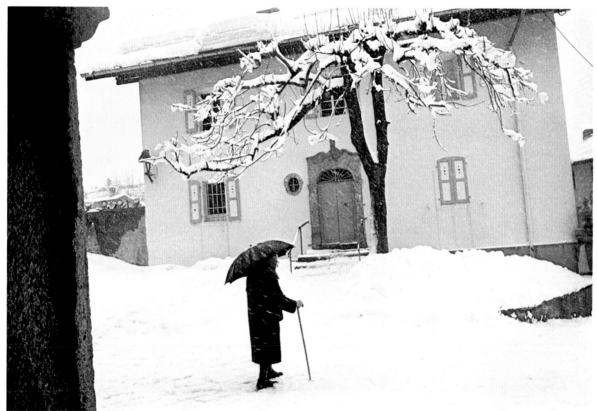

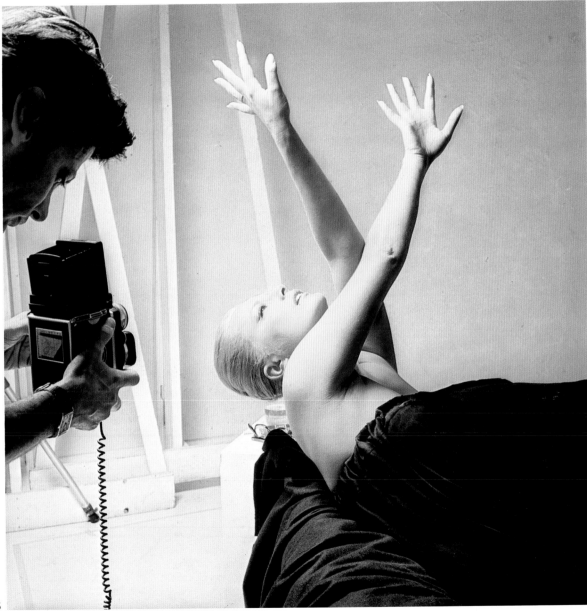

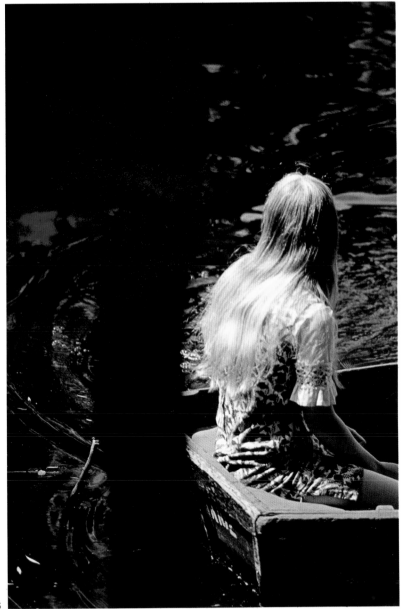

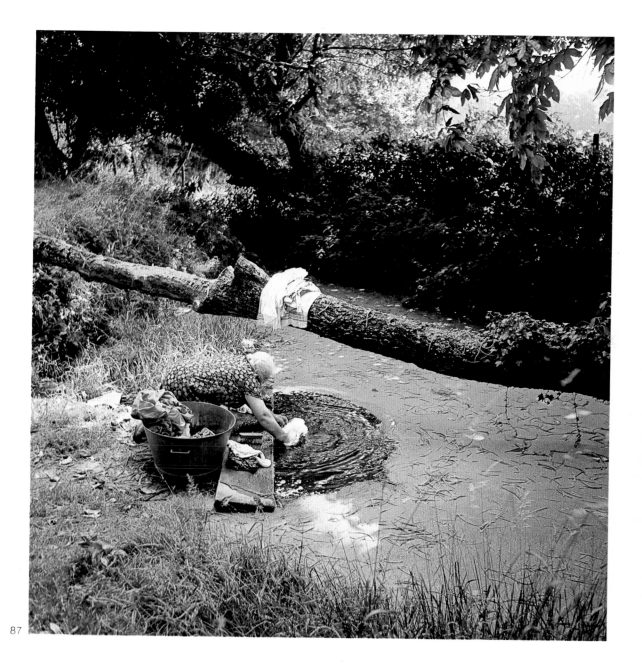

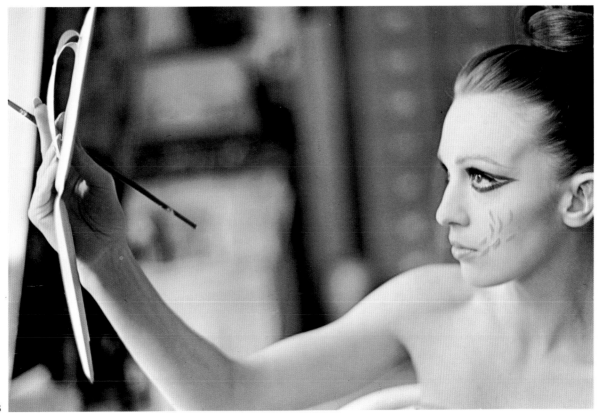

88

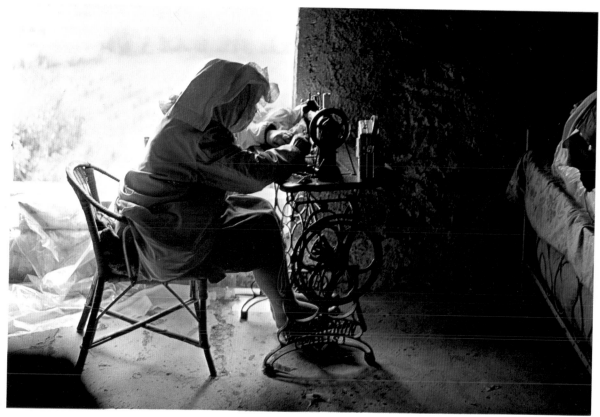

89

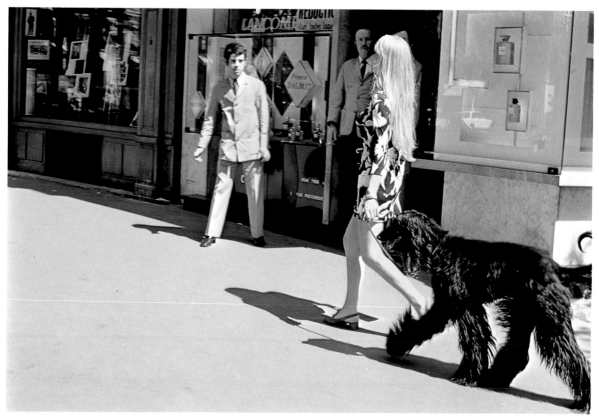

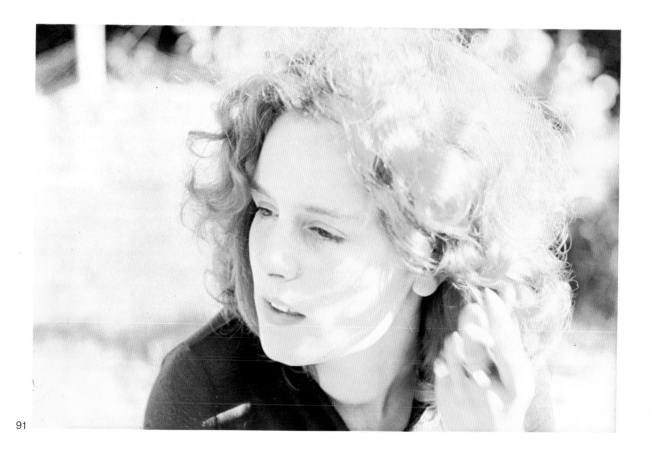

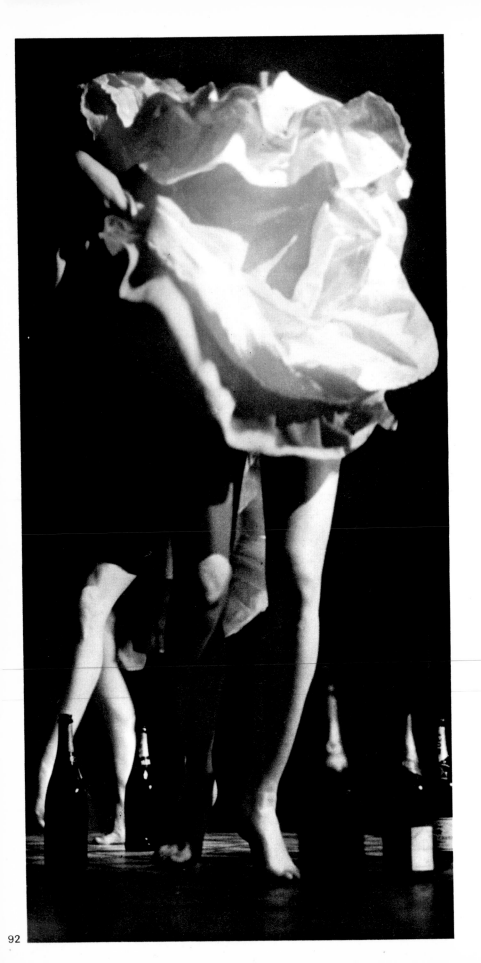

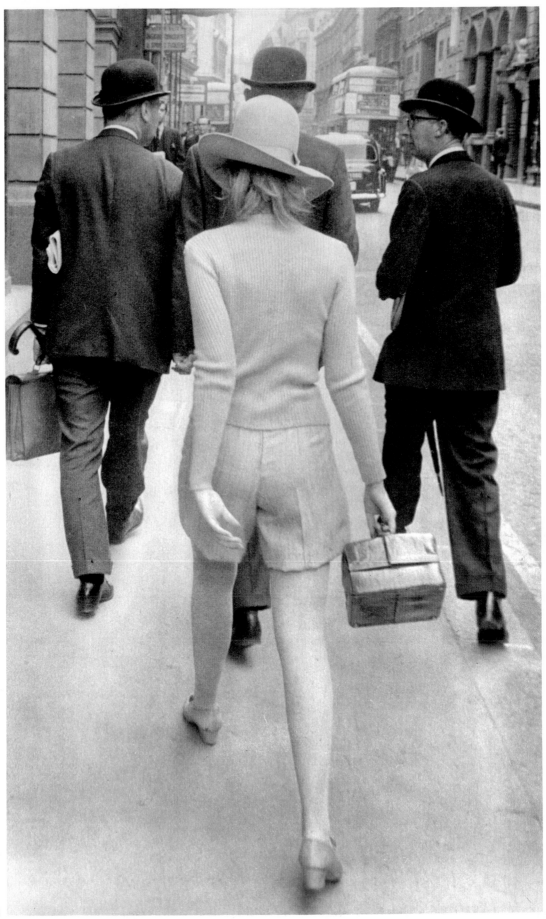

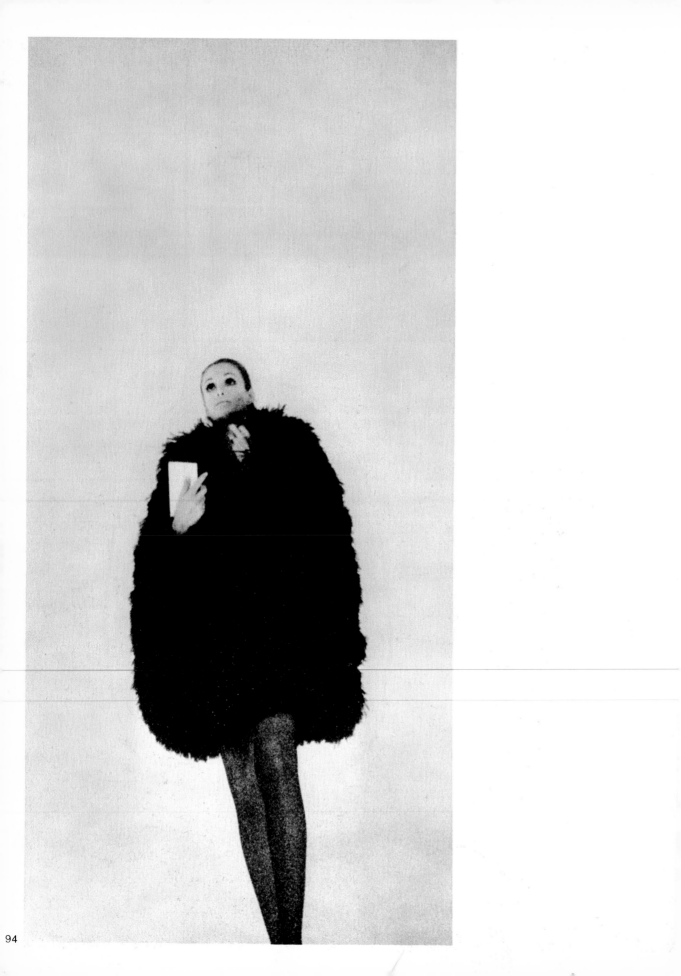

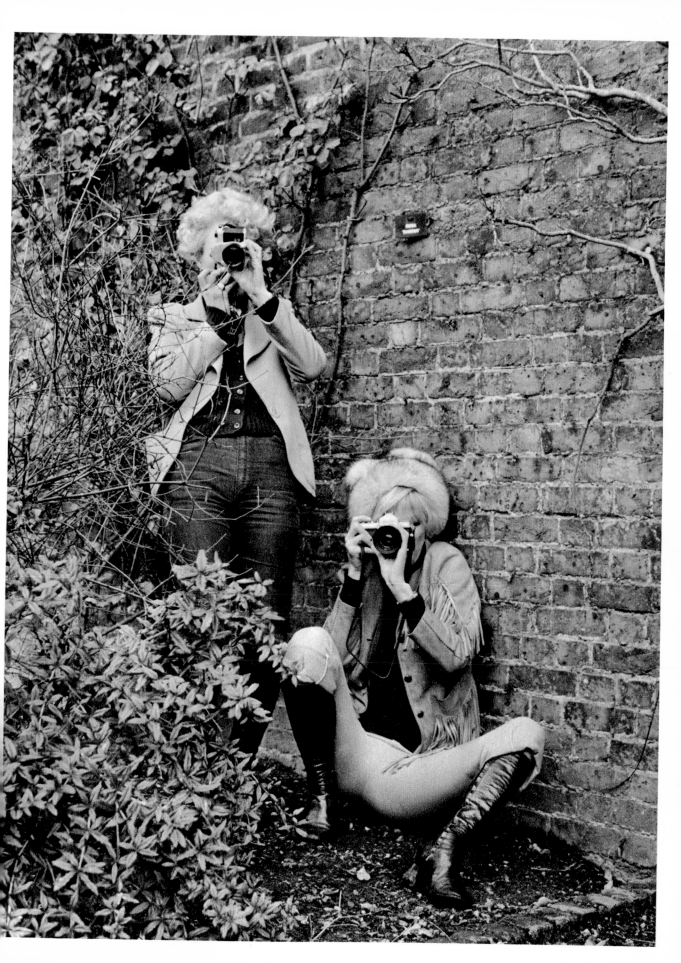

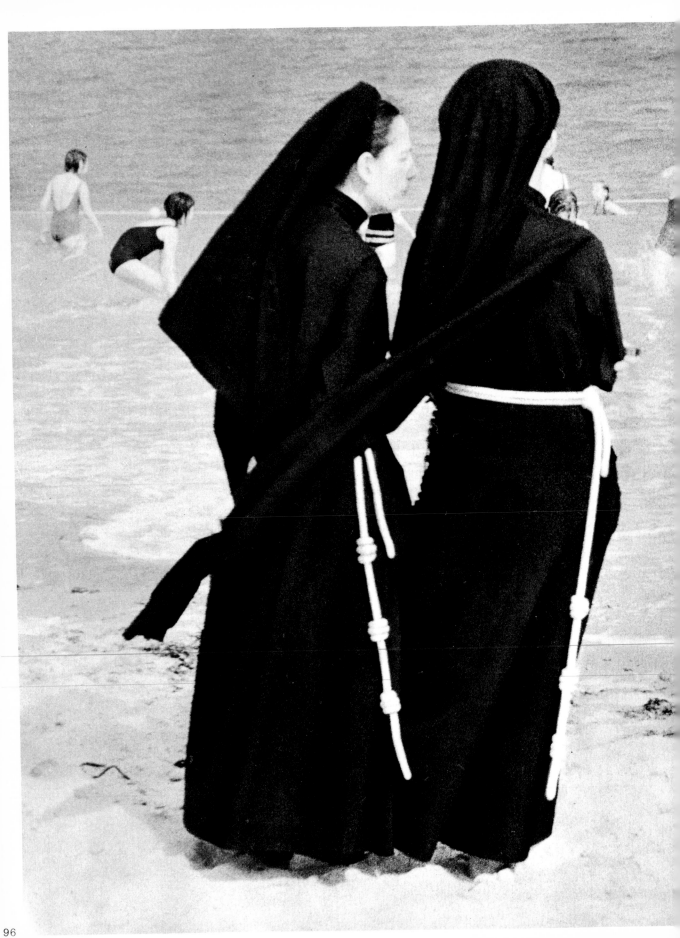

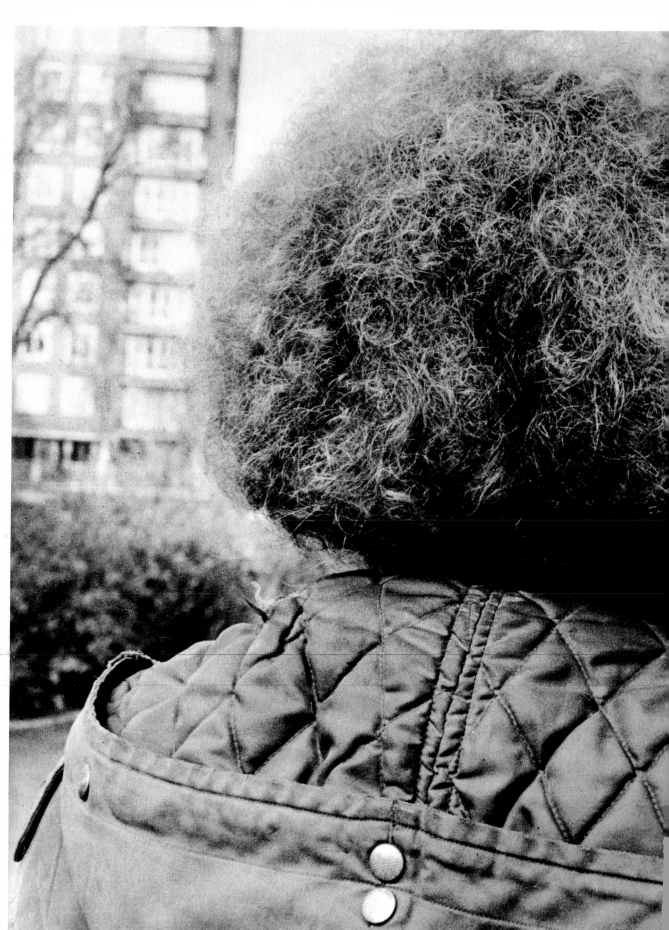

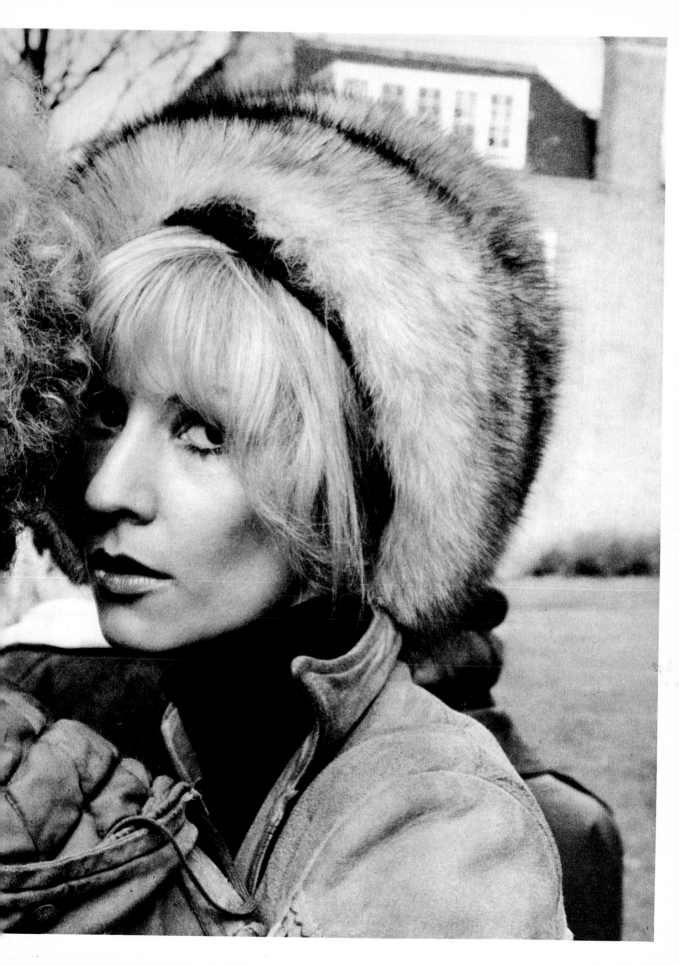

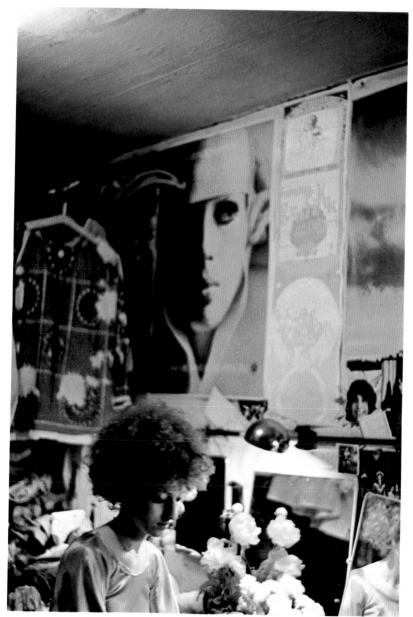

98

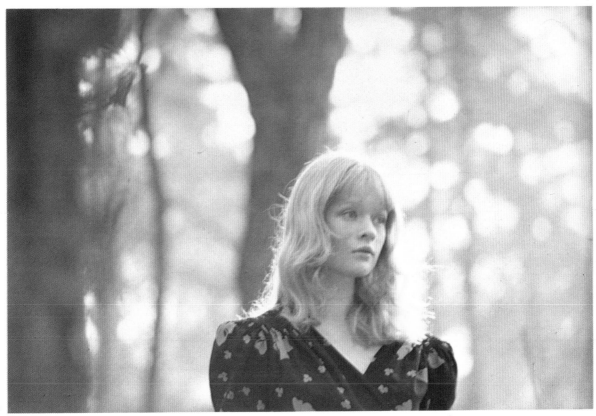

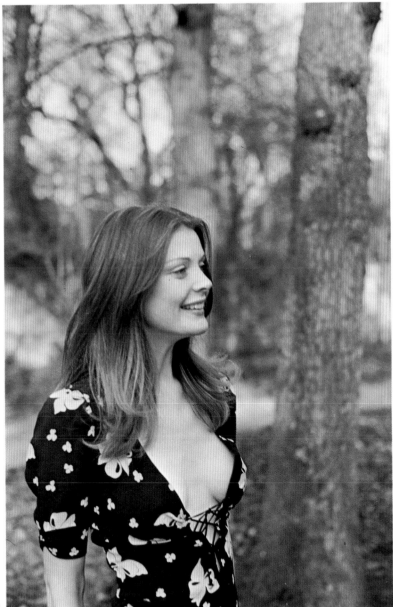

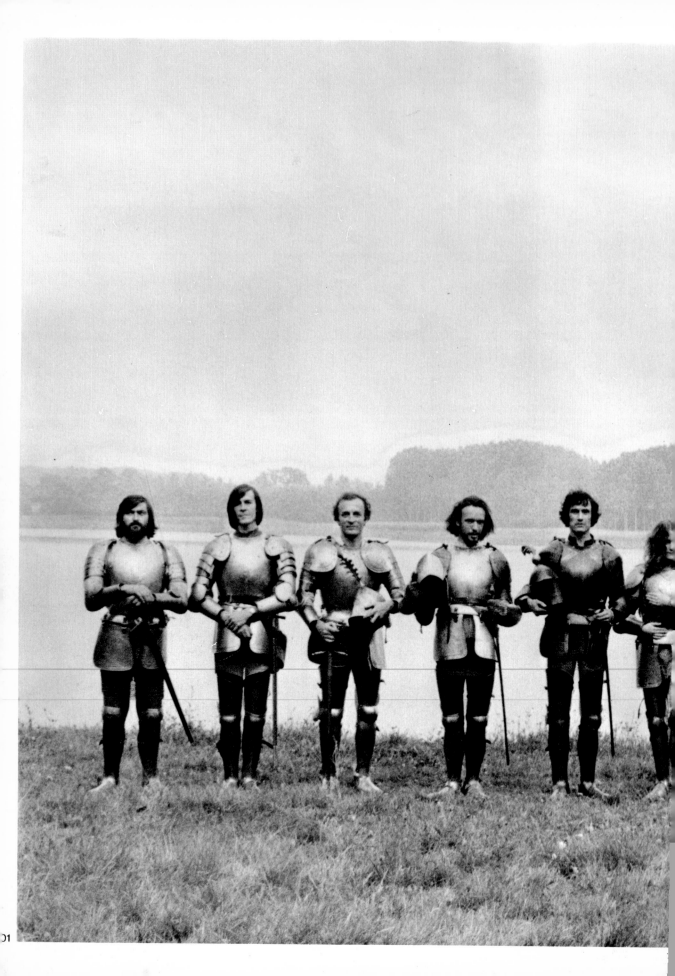

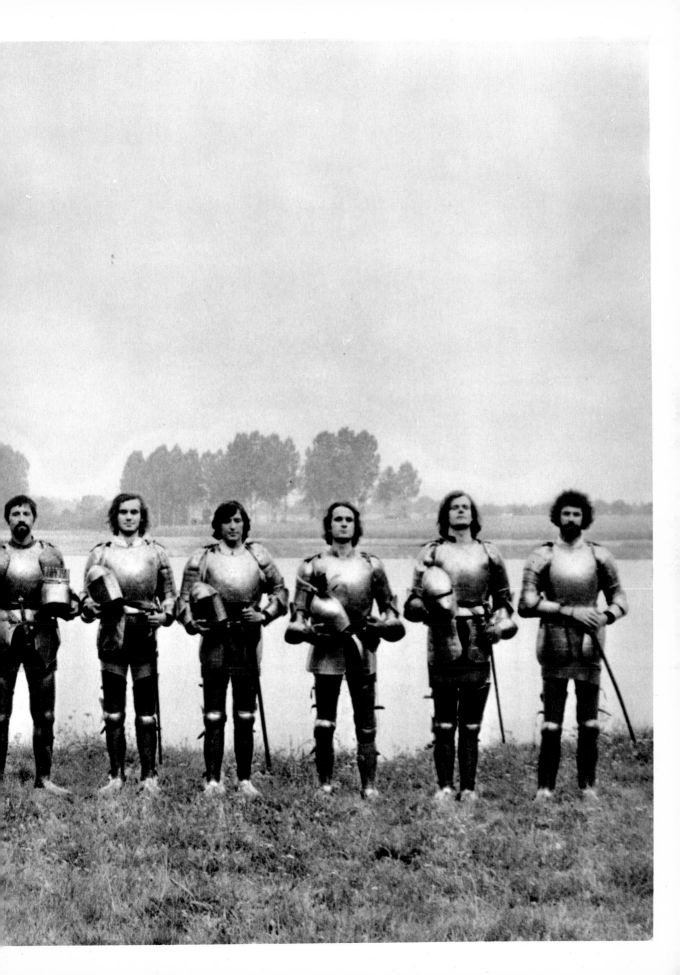

THE CAMERAS I HAVE USED

For the first three-quarters of my life as a photographer I was not concerned with ASAs or light meters. I used to buy so-called rapid plates with which, after a bit of practice, few photographs failed. (It should be remembered that only twelve plates at the maximum could be carried, after which the photographer was obliged to return to his darkroom to reload his camera.) Having a curtained camera capable of operating at one/thousandth of a second, I needed strong sunlight in order to use its maximum speed. For spontaneous photos, I mostly used one/five-hundredth of a second, until the day (in about 1911) I discovered some very sensitive English plates (made by Ilford), called "extra-rapid."

As for focusing, I rarely made a mistake, regularly practicing calculating the distances between objects at home, which I then verified with a ruler. These days, highly perfected cameras have cut out all that work. But I still prefer cameras that are not entirely automatic, for the highly automatic ones make it difficult to capture what I seek from the subject I am photographing.

In summary, I believe that while knowledge of technique is a useful basis (and so relatively easy to learn), it should nevertheless remain a supplementary tool of the photographer who, like the painter or even the writer, must above all have eyes to see, obedient reflexes, and a heart to love, understand, divine and attempt to capture the passing things of life.

<div align="right">J.H.L.</div>

Camera No. 1—5″ x 7″ (13 x 18 cm) box with tripod—no shutter (cover that has to be removed and replaced) 1902–1903

Camera No. 2—manual folding—nonpliant, 3½″ x 4¾″ (9 x 12 cm) plates, shutter speed 1/50th second 1903–1904

Gaumont "Block notes" with 1½″ x 2½″ (4.5 x 6 cm) plates—opening F.8—shutter speed 1/100th second—6 plate-holders 1904–1908

Gaumont "Block notes" with 1½″ x 2½″ (4.5 x 6 cm) plates—Tessar-Zeiss lens, opening F.6.3, shutter speed 1/300th second—6 plate-holders, magazine 12 plates 1906–1912

Folding Kodak "Brownie No. 2," 2½″ x 3½″ (6 x 9 cm) film—shutter speed 1/100th second 1905–1909

Klapp-Krauss-Zeiss with 3½″ x 4¾″ (9 x 12 cm) plates—curtain shutter, speed 1/1000th second, Zeiss lens, opening F.4.5—3 double plate-holders and magazine 12 plates 1910–1914

Spido-Gaumont 2½″ x 5″ (6 x 13 cm) stereoscope (or panoramic)—magazine 12 plates—3 double plate-holders—Zeiss lens, opening 6.3—shutter speed 1/300th second (camera loaned to me by Papa) 1904–1910

Klapp Nettel 2½″ x 5″ (6 x 13 cm) stereoscope (or panoramic)—Zeiss lens, opening F.4.5—curtain shutter, speed 1/1200th second—3 plate-holders—2 magazines 12 plates—(and another the same, purchased second-hand in Nice) 1912 . . . 1938 . . .

Ernemann Reflex 3½″ x 4¾″ (9 x 12 cm)—Zeiss lens, opening 4.5 (and tele-photo lens, rarely used)—curtain shutter, speed 1/1000th second—6 plate-holders and 1 magazine 12 plates—Pack film plate-holders
 1910 . . . 1938 . . .

Ica Reflex 2½″ x 3½″ (6 x 9 cm) (Prototype)—Zeiss lens, opening 1/5—Pack film magazine and plateholder—curtain shutter, speed 1/1000th second
 1930–1938

Folding Kodak—3¼″ x 5½″ (8 x 14 cm) film, 6.8 lens—shutter 1927–1939

Kodak "West-Pocket," 1¾″ x 2½″ (4.5 x 6 cm) film—6.8 lens—shutter
 1916–1936

5″ x 7″ (13 x 18 cm) wooden box—wide-angle Goerz lens, opening F:24—
6 double plate-holders (cover that has to be removed and replaced)
1922–1936

Panoramic Kodak No. 4—capable of taking 4 photographs 3¾″ x 12″ (9.5 x
31 cm) with 4″ x 5″ (10 x 12.5 cm) film—Horthostigmat revolving lens,
1:8—(camera seldom used) 1912–1933

Manual "Grand Folding" camera—folding "Demaria"—lens 1:8.6, for 9½″ x
12″ (24 x 30 cm) plates—6 double plate-holders with curtain (camera
seldom used) 1910–1930

Spido Gaumont Stereoscope with 3″ x 5½″ (8 x 14 cm) plate—6 plate-
holders—Zeiss lens 1:6.8—shutter speed 1/300th second (camera seldom
used) 1908–1920

Leica (camera loaned to me occasionally)—lens 1: 2/3.5 1935–1939

Rolleiflex 2½″ x 2½″ (6 x 6 cm) (with film), semi-automatic—lens 1:3.5
1935–1946

Rolleiflex 2½″ x 2½″ (6 x 6 cm) automatic—Elmar lens, 3.5 1946–1950

Rolleiflex 2½″ x 2½″ (6 x 6 cm) automatic—Zeiss lens—1: 3.5/75
1950 . . . 1973 . . .

Leica "D.R.P.," wide-angle—Summar lens 1: 5.6/28 1964 . . . 1973 . . .

Leica M.2—Summicron lens 1: 2/50 1968 . . . 1973 . . .

Pentax—Super-Takumar lens, 1: 1.8/55 1964 . . . 1973 . . .

Pentax Spotmatic—Super-Takumar tele. 1:4/200 1969 . . . 1973 . . .

Canon Fix—Lens 1:1.8/50 1967 . . . 1973 . . .

Little Canon "Dial 35-2"—Lens 1:2.8/28 1971 . . . 1973 . . .

Yashica 24, 2½″ x 2½″ (6 x 6 cm) films—Yashinon lens, 1:3.5/80
1967 . . . 1973 . . .

Various Pentaxes with different lenses 1972 . . . 1973 . . .

NOTES TO THE PLATES

1 Mama, Grandmama and myself, posing for Papa, 1903
2 Mama and Mrs. Folletête in the Bois de Boulogne, a Dion Bouton, an early car, in the background, 1903
3 Spain, 1905
4 Picnic lunch, 1906
5 My Fraulein Ketchen, Dudu, and the chambermaids of the castle, Rouzat (Auvergne), 1909
6 Aunt Amélie and Mama at Rouzat, 1909
7 Ketchen and Dudu being shipwrecked on a home-made raft, Rouzat, 1909
8 Ketchen at Menton, 1908
9 Mama and Mr. Laroze in the Chevreuse Valley, 1911
10–12 Avenue of the Bois de Boulogne, 1911
13 Bois de Boulogne
 Marie Lancray arrives at the "Path of Virtue," 1912
14–17 Midday, Path of Virtue, 1911
18 Five o'clock in the evening, Avenue of the Acacias, 1911
19 Fashion at the races. Drag-races Day, 1911
20–21 Path of Virtue, 1912
22 Mrs. de Grandval, Avenue of the Acacias, 1912
23 Avenue of the Bois de Boulogne, 1912
24 Mama and my griffon, Rags, 1911
25 Mrs. de Grandval and a friend, afternoon, Avenue of the Acacias, 1913
26 The actresses Alice Clairville and Gaby Boissy, morning, Avenue of the Bois de Boulogne, 1913
27 Path of Virtue, 1913
28 Avenue of the Acacias, 1912
29 Soldier on leave strolling on the Path of Virtue, 1915
30 Lilian Mur at the wheel of my B.B. Peugeot in the Bois de Boulogne, 1915
31 Bibi, Mama and my father-in-law André Messager at the Cap d'Antibes, 1921

32 The actress Peggy Vere on the running-board of my Pic-Pic car, Deauville, 1919

33 Madeleine Bourgeois and Germaine Bourgeois in Paris, 1914 (autochrome)*

34 Bibi at the Garoupe castle, Cap d'Antibes, 1920 (autochrome)

35 Bibi in the new Eden Roc restaurant, Cap d'Antibes, 1920 (autochrome)

36 Bibi at Cap d'Antibes, 1920 (autochrome)

37 Bibi at Nice, 1921 (autochrome)

38 Bibi at Nice, 1921 (autochrome)

39 Bibi on the Saint-Honorat Isle, 1921 (autochrome)

40 Bibi at Rouzat, 1921 (autochrome)

41 Bibi and Germaine Chalom at Cannes, 1927 (autochrome)

42 Bibi at Cannes, 1927 (autochrome)

43 Bibi at Rouzat, 1922

44 Bibi and Dédée Messager at Rouzat, 1920

45 World tennis champion Suzanne Lenglen at Cannes, 1920

46 Bibi and my son Dany in the arms of Nun's, Paris, 1922

47 Bibi and film actress Louise Lagrange at Trouville, 1922

48 Bibi and Dany, a stroll before bathing, Rouzat, 1922

49 Bibi and Georgette Puiforcat at "La Feuilleraie," Melun, 1922

50 Bibi at Mouxy, Savoie, 1924

51 Yvonne Printemps at Royan, 1924

52 Royan, 1924

53 Yvonne Printemps at Royan, 1926

54 Ila Mery at the Cap d'Ail, 1932

55 The Dolly Sisters, Paris, 1927

56 Bibi at Nice, 1927

* Autochromes: Glass plates emulsified and coated with a fine layer of powdered starch colored in the following proportions: ⅓ red, ⅓ green, ⅓ blue. The emulsion, on the reverse side of the plate, that is to say facing the photographer, received the impression through the glass; the negative obtained was transformed into a positive by isolation.
 This technique, developed by the Lumiere brothers in 1903, was commercialized from 1907 until 1932.